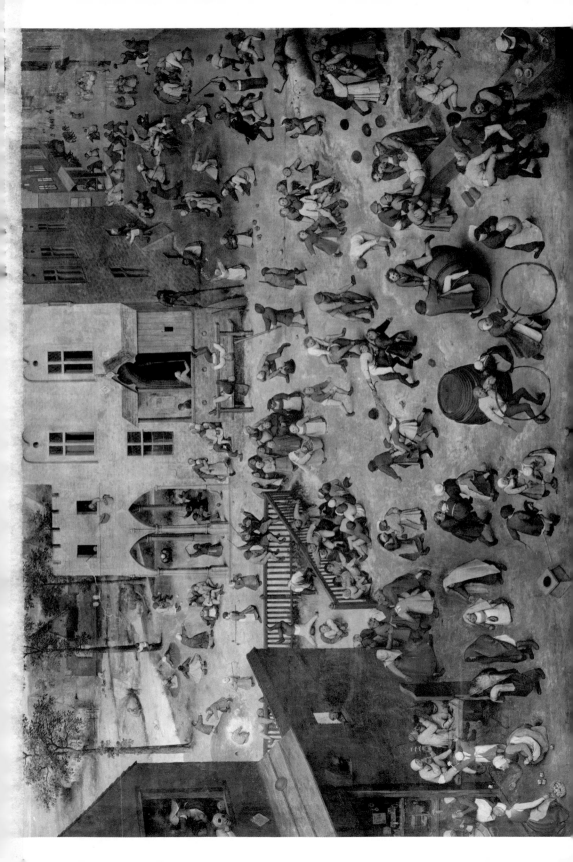

Front Cover Drawing
Painter and Patron (with Bruegel's Self Portrait), circa 1565
Pen and ink, 10 x 8 1/2 in
Graphische Sammlung Albertina
Vienna

Overleaf (Plate 14)
Children's Games 1560,
Oil on panel, 46 1/2 x 63 3/8 in
Kunsthistorisches Museum
Vienna

PAINTING LIFE

THE ART OF PIETER BRUEGEL, THE ELDER

PAINTING LIFE

THE ART OF PIETER BRUEGEL, THE ELDER

ROBERT L. BONN

Chaucer Press Books

An Imprint of Richard Altschuler & Associates, Inc.
New York

Painting Life: The Art of Pieter Bruegel, The Elder. Copyright© 2006 by Robert L. Bonn. For information contact the publisher, Richard Altschuler & Associates, Inc., at 100 West 57th Street, New York, NY 10019, RAltschuler@rcn.com or (212) 397-7233.

To personally correspond with the author, Robert L. Bonn, please visit www.bonnbooks.com

Library of Congress Control Number: 2006905686

ISBN-10: 1-884092-12-8

ISBN-13: 978-1-884092-12-1

Chaucer Press Books is an imprint of Richard Altschuler & Associates, Inc.

Cover Design and Layout: Josh Garfield

Cover Photograph: R. Sebazco

Printed in China

Contents

Acknowledgements

The author would like to thank the following art reference services, museums, collections and photographers for granting permission to reproduce images of the artworks displayed in this book.

Plate 1: Private Collection/The Bridgeman Art Library
 Netherlandish/out of copyright

Plate 2: Erich Lessing/Art Resource, NY
 Museo del Prado, Madrid, Spain

Plate 3: Erich Lessing/Art Resource, NY
 Kunsthistorisches Museum, Vienna, Austria

Plate 4: Erich Lessing/Art Resource, NY
 Kunsthistorisches Museum, Vienna, Austria

Plate 5: Erich Lessing/Art Resource, NY
 Kunsthistorisches Museum, Vienna, Austria

Plate 6: Erich Lessing/Art Resource, NY
 National gallery, Prague, Czech Republic

Plate 7: The Metropolitan Museum of Art, Rogers Fund, 1919 (19.164)
 Photograph © 1998 The Metropolitan Museum of Art

Plate 8: Scala/Art Resource, NY
 Musee d'Art Ancien, Musees Royaux des Beaux-Arts, Belgium

Plate 9: Collection Oskar Reinhart "Am Roemerholz," Winterthur, Switzerland

Plate 10: Erich Lessing/Art Resource, NY
 Kunsthistorisches Museum, Vienna, Austria

Plate 11: Nimatallah/Art Resource, NY
 Kunsthistorisches Museum, Vienna, Austria

Plate 12: Erich Lessing/Art Resource, NY
 Kunsthistorisches Museum, Vienna, Austria

Plate 13: Erich Lessing/Art Resource, NY
 Kunsthistorisches Museum, Vienna, Austria

Plate 14: Erich Lessing/Art Resource, NY
 Kunsthistorisches Museum, Vienna, Austria

Plate 15: Erich Lessing/Art Resource,NY
 Kunsthistorisches Museum, Vienna, Austria

Plate 16: Erich Lessing/Art Resource, NY
 Kunsthistorisches Museum, Vienna, Austria

Plate 17: Erich Lessing/Art Resource, NY
 Kunsthistorisches Museum, Vienna, Austria

Plate 18: City of Detroit Purchase
 Photograph © 1984 The Detroit Institue of Arts

Plate 19: Erich Lessing/Art Resource, NY
 Kunsthistorisches Museum, Vienna, Austria

Plate 20: Bildarchiv Preussischer Kulturbesitz/Art Resource, NY
 Gemaeldegalerie, Staatliche Museen zu Berlin, Berlin, Germany

Plate 21: Erich Lessing/Art Resource, NY
 Museum Mayer van den Bergh, Antwerp, Belgium

Plate 22: Museum Mayer van der Berg, Belgium, Giraudon/The Bridgeman Art
 Library
 Netherlandish/out of copyright

Plate 23: Scala/Art Resource, NY
 Musee d'Art Ancien, Musees Royaux des Beaux-Arts, Brussels, Belgium

Plate 24: Scala/Art Resource, NY
 Musee d'Art Ancien, Musees Royaux des Beaux-Arts, Brussels, Belgium

Plate 25: National Trust/Art Resource, NY
 Upton House, Bearsted Collection, Banbury, Oxfordshire, Great Britain

Plate 26: Reunion des Musees Nationaux/Art Resource, NY
 Louvre, Paris, France

Plate 27: Allinari/Art Resource, NY
 Galleria Doria Pamphili, Rome, Italy

Plate 28: Erich Lessing/Art Resource, NY
 Museo Nazionale di Capodimonte, Naples, Italy

Plate 29: Erich Lessing/Art Resource, NY
 Museo Nazionale di Capodimonte, Naples, Italy

Plate 30: The Putnam Foundation
 Timken Museum of Art, San Diego, CA

Plate 31: Erich Lessing/Art Resource, NY
 Museum of Fine Arts (Szepmuveszeti Muzeum), Budapest, Hungary

Plate 32: National Gallery, London, UK/The Bridgeman Art Library
 Netherlandish/out of copyright

Plate 33: Foto Marburg/Art Resource, NY
 Hessisches Landesmuseum, Darmstadt, Germany

Plate 34: Reunion des Musees Nationaux/Art Resource, NY
 Louvre, Paris, France

Plate 35: Scala/Art Resource, NY
 Alte Pinakothek, Munich, Germany

Plate 36: Bildarchiv Pressischer Kulturbesitz/Art Resource, NY
 Gemaeldegalerie, Staatliche Museen zu Berlin, Germany

Plate 37: Kavaler/Art Resource, NY
 Museum Boymans van Beuningen, Rotterdam, The Netherlands

Front Cover Drawing: Erich Lessing/Art Resource, NY
 Graphic Sammlung Albertina, Vienna, Austria

Author's Preface

PAINTING LIFE is a journey through the social worlds depicted in 36 major paintings of Pieter Bruegel, The Elder. A Flemish Renaissance painter who lived from 1520/25 to 1569, Bruegel has long been known both as anthropologist and as social philosopher of art. His paintings are rich with hidden meanings that often tell us "something more" than the particular scenes that are depicted. This book explores the "something more" that Bruegel put into his art. Sometimes it tells us of social change. Sometimes it portrays social conflict. It can also depict a universal social truth or an important social myth. It can even show the folly or the social chaos that is so much a part of our human condition. Whatever it is, the messages portrayed in Bruegel's paintings are so compelling that his art has for centuries not only delighted and enchanted us but also provided great insight into who and what we are.

To explore the complex of meanings in Bruegel's art, I take a personal approach and discuss his paintings roughly in the order I came to know them. *Winter Landscape with Skaters and a Bird Trap* was the first of his works to capture my attention, when I visited The Prado in Madrid in 1972. Viewing this

dynamic painting left me with the foreboding sense that the idyllic life of the 16th century Flemish countryside was about to be shattered, as the skaters blithely glided along on the thin ice, and the birds too casually nibbled at the bait in the trap that had been set for them. The painting portrays volumes about the encroachment of cities and suburbs upon the countryside, a long-term social trend that began in Bruegel's time and continues to this day. Another very different painting at The Prado, his *Triumph of Death*, is equally powerful in its portrayal of how we, the living, actively confront the world of the dead.

My journey into the social worlds captured on canvas by Pieter Bruegel, The Elder expands greatly with a visit to Vienna 25 years later. The famous Bruegel Room of Vienna's Kunhistorisches Museum, houses a treasure trove of his work. While looking at the art displayed in this room, I invite you to experience, just as I did, not only Bruegel's wonderful naturalistic depictions of seasonal life in the Middle Ages, but also his portrayals of the social abnormalities of suicide, religious conversion and crucifixion; his comprehensive, multiple activity paintings of children's games and the tension between our material and spiritual selves; his paintings of peasant life; and, finally, a morality painting in which he depicts a key peasant proverb of his times. As in the Madrid chapter, I discuss each painting in depth, showing how it depicted the society of Bruegel's day, and how/why it continues to fascinate us today.

From Vienna the journey proceeds in Chapter 3 to Brussels and Antwerp, cities in which Bruegel lived and worked, and where a number of his paintings are on exhibit in their museums. Again, it is fascinating to see how the paintings portray both the social life of Bruegel's times and, curiously, that of ours. In Antwerp we also see how Bruegel incorporated the imagery of the places he lived into his paintings. Following the trip to Brussels/Antwerp, we shift our attention to Rome and Naples, cities where there are other Bruegel paintings, and to which Bruegel

himself traveled in 1552-54. Here we appreciate how Bruegel gained perspectives through his travel that he then incorporated into his art, especially with his use of the coliseum of Rome, as a powerful symbol for his painting, *The Tower of Babel*.

After Rome and Naples, our travel into the worlds depicted by Bruegel expands to other cities where his paintings can be seen from far west as San Diego in the United States to as far east as Prague in Eastern Europe. Since the range of social themes depicted in these paintings is enormous, I have grouped them in terms of how they relate to four of the five types of societies that made up the medieval social order of Bruegel's day. So, for example, when we take the theocratic society, we find that Bruegel's religious works run the gambit from the serene *Parable of the Sower* to the skeptical, almost irreverent, *Saint John the Baptist Preaching*. When it comes to the emerging territorial state, we cannot miss Bruegel's biting critique of social power in his *Landscape with Magpie on the Gallows*, in which a man in peasant dress mocks the power of the state by defecating on its gallows.

Set in New York, the final chapter is about seeing social order from what I call a "Tower of Babel" viewpoint. *The Tower of Babel* (in Vienna) has long been my favorite Bruegel painting. The power of Bruegel's art is dramatically apparent in this painting, because it allows us to visualize all of the elements of the Biblical story, namely, the human pride of the builders of the tower and each of God's three punishments: the confusion of languages, the imperfect construction of the tower, and the diaspora of the peoples. In addition, the painting transcends time because Bruegel used the symbol of the coliseum in Rome to represent the tower. Seen from this viewpoint, *The Tower of Babel* allows us to take a "Bruegelian perspective" on places and times unknown to Bruegel, including New York City and the tragic events of 9/11/01. With this perspective we can appreciate the considerable extent to which chaos is embedded in what we think of as social order.

While the intellectual journey of PAINTING LIFE is told as personal observation, it draws upon the opinions of professional experts whose work is cited wherever possible. Reference notes and the sources of quotations are placed in a section of page notes in the back of the book so that they do not interfere with your reading of the text. In all, the intent is to show how Bruegel's art captured the essence of what we think of as "society" so well that it remains as compelling to us today as it was to those living in the times in which he painted.

I would like to thank my wife, Patricia, who has shared enormously in this personal journey into what I have come to think of as the world according to Bruegel. I would also like to acknowledge the contributions of Adam Sexton, whose editorial assistance was invaluable in the formative stages of the book, and of Isaac Tylim, with whom I had many conversations about the complexity of meanings found in Bruegel's art. More generally, I would like to acknowledge the encouragement of the many I have met in my travels who responded with supportive enthusiasm and excitement, when they learned that I was busy writing a book on the art of Pieter Bruegel.

Let me invite you to share my personal excitement with the wonderful art of Pieter Bruegel. As you read the book, look at the art. If something captures your attention, examine it more closely. Enjoy it. See it for what it is and ask what it means to you, personally, and to us, as a society. Realize that all art is about perspective, and try to see the world through Bruegel's eyes. As you do this, my hope is that you will, as I did, come to understand how Bruegel's art enables us to see and understand both the worlds of 16th century Europe and our familiar, mundane 21st century in new and exciting ways.

<div style="text-align:center">Robert L. Bonn
New York City</div>

Paintings Of Pieter Bruegel, The Elder, Dated By Year

A. Discussed in *Painting Life*

Year Dated	Title of Painting (Plate Number)
1557	*Parable of the Sower* (Plate 30)
1558	*Landscape with the Fall of Icarus* (Plate 23)
1558-60	*Twelve Proverbs* (Plate 22)
1559	*Fight between Carnival and Lent* (Plate 15)
1559	*The Netherlandish Proverbs* (Plate 36: Overleaf)
1560	*Children's Games* (Plate 14: Overleaf)
1560-62	*A View of Naples* (Plate 27)
Ca. 1562	*Dulle Griet* (*Mad Meg*) (Plate 21)
1562	*Fall of the Rebel Angels* (Plate 24)
1562	*The Suicide of Saul* (Plate 11)
1562	*Two Chained Monkeys* (Plate 20)
Ca. 1562	*Triumph of Death* (Plate 2)

1563	*The Tower of Babel* (Vienna) (Plate 13)
1564	*The Adoration of the Kings* (Plate 32)
1564	*The Massacre of the Innocents* (Plate 25)
1564	*The Way to Calvary* (Plate 12)
1565	*The Dark Day* (Plate 4)
1565	*The Harvesters* (Plate 7)
1565	*Haymaking* (Plate 6)
1565	*The Return of the Herd* (Plate 5)
1565	*Return of the Hunters* (Plate 3)
1565	*Winter Landscape with Skaters and a Bird Trap* (Plate 1)
1566	*The Census at Bethlehem* (Plate 8)
1566	*Saint John the Baptist Preaching* (Plate 31)
1566	*The Wedding Dance* (Plate 18)
1567	*The Adoration of Kings in the Snow* (Plate 9)
1567	*Conversion of Saint Paul* (Plate 10)
1567	*The Land of the Cockaigne* (Plate 35)

1568 *The Beggars* (Plate 34)

1568 *The Blind Leading the Blind* (Plate 28)

1568 *Landscape with Magpie on the Gallows* (Plate 33)

1568 *The Misanthrope* (Plate 29)

1568 *Peasants' Dance* (Plate 16)

1568 *The Peasants' Wedding* (Plate 17)

1568 *The Poacher* (Plate 19)

1568 *The Tower of Babel* (Rotterdam) (Plate 37)

B. Other Paintings

1556-62 *The Adoration of the Kings*
 Brussels, Musees Royaux des Beaux-Arts

1557 *The Temptation of St. Anthony*
 Washington, D.C., National Gallery of Art

1558 *The Three Soldiers*
 New York, The Frick Collection

1563 *Landscape with the Flight into Egypt*
 London, Courtauld Institute Galleries

1564 *The Death of the Virgin*
 Banbury, National Trust,Upton House

Chapter 1
Madrid, 1972

I t is often said that we can understand ourselves in the present, if we but look to the past. That is why we read history, study the works of great thinkers, and view art or listen to music created decades or centuries ago. When Leonardo, Michelangelo, Brunelleschi and others who lived in the fifteenth century brought ancient Greek and Roman ideas into the life of their times, they ignited a renaissance that gave birth to Western civilization as we know it. In the centuries that followed, scholars, artists and many others would look to the Renaissance for ideas to shed light on their own times.

Looking to the past to understand the present is something we all do. Many of us have sought to discover family roots, in order to place ourselves in the larger scheme of things. Others have read the classics for insights into the person we are or would like to become. The writer Michael Gelb has asserted that we can live a richer, fuller life by learning how to think like the great Leonardo. Alain de Botton suggested that we look to Proust to find new paths of personal growth. Harold Bloom proposed that we mine Shakespeare's plays and sonnets for insights into human nature, which are so great it can only be said Shakespeare wrote the

script by which we live. As Bloom would have it, we need to understand the Bard because he "invented" us.

For me, the search into the past to shed light on the present need go no further than the art of Pieter Bruegel, The Elder, the Flemish painter who was born sometime between 1520 and 1525 and lived until 1569. To look at almost any Bruegel painting (I focus on his major works in this book) is to be at once transported back to life as it was known more than four centuries ago. But that's not all. With Bruegel, a second, deeper look invariably reveals a certain "something more." This "something more" varies from painting to painting. It may be secular or religious. It may be a proverb, a moral, a philosophical dilemma or a social myth. Whatever it is, I have often found it to be strikingly modern. In fact, if you take the advice of Thomas Hoving, that the key to becoming a connoisseur of art is to "look and look more and look again," and apply it to Bruegel, then you will find frequently that the first look reveals a very beautiful painting of a scene, as it may have appeared centuries ago, while the second, third and later looks allow you to see our own social and personal lives differently. For instance, when we look at Bruegel paintings, we can see children's games being played by adults (as in *Children's Games*), a country landscape scene that shows how precarious it is to skate on thin ice (*Winter Landscape with Skaters and a Bird Trap*), a collage of grotesques that points out the conflict between our spiritual and material selves (*Fight between Carnival and Lent*) or the sense of a religious sermon being preached, in which some of the all-too-human listeners are more caught up in the distractions of life than in the sermon (*Saint John the Baptist Preaching*).

The charm of Bruegel paintings is that they incorporate worlds of our real experience into the scenes depicted. The characters are never posed. We see them at work, at play, dancing, and expressing the scorn we feel about authority that is unjust. With few exceptions, the paintings are landscapes that offer a background

or "contextual" setting for the activities shown. This rather unique combination of actual experience within a landscape led Leo J. Koerner, of Harvard, to coin the word "worldscape" to describe the unique quality of many Bruegel paintings:

> Whenever we look we enter, through details and anecdotes, into an experience of being in that world, as if the terrain stretching before us were an experience park. But the picture's own viewpoint remains more capacious than ordinary experience. Simultaneously landscape and map, Bruegel's paintings endow sight with the proportions of the world.

Because Bruegel depicted so many aspects of social reality in his "worldscapes," his paintings provide a wealth of insights into the society of his day—and ours.

My first encounter with the world of Bruegel paintings occurred in 1972, when I visited Madrid, Spain, and went to its great art museum, the Prado. The museum was full of many wonderful, old-master paintings, but there were two Bruegels that I found so powerful and full of meaning I could not pass them by. I had to give them a second look and, though I did not realize it at the time, was destined to think about them for years afterwards.

The first, *Winter Landscape with Skaters and a Bird Trap* painted in 1565, depicts feelings we all have about social change. (See Plate 1.) At first sight, it appears to be a straightforward, idyllic winter scene of a Flemish village, complete with snow-capped houses and skaters enjoying an afternoon of leisure. A city looms in the background of an idealized rural village. A large crow, far too ominous to be just another bird, is perched on a branch in the upper right corner. The other birds bear a curious resemblance to the humans. Both the crows and humans are painted mostly in black. The two birds perched on the branch of the tree that overhangs the pond are painted the same size as the people skating. We

are left to wonder. Could it be that the birds and the people share some common predicament? Given the trap, could the predicament be one that foreshadows some kind of impending doom?

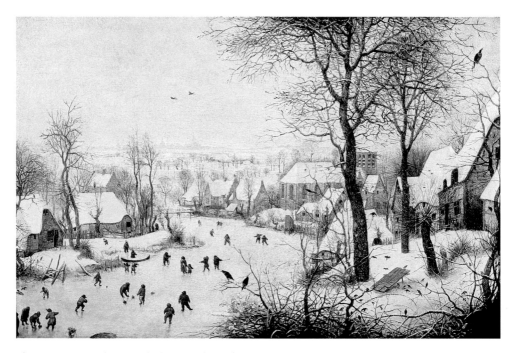

Plate 1: *Winter Landscape with Skaters and a Bird Trap,* 1565
Oil on panel,15 x 22 in
Private Collection
Giraudon

To put it another way, *Winter Landscape with Skaters and a Bird Trap* is far more than a 16th century Flemish landscape. The painting makes you *think*. The more you think about it, the more you wonder what Bruegel was trying to portray. Are the birds in the lower right corner about to be caught in the trap because they have taken the bait too casually? Or, is it the people who are in danger, although seemingly skating without a care in the world, on what is all-too-thin ice? Should you pose these questions, you would hardly be alone. Some earlier observers of the

painting have concluded that it illustrates a foolishness found in both humans and birds. Others have given a more pointed interpretation: the painting demonstrates the slipperiness of life (for both species).

In *Winter Landscape with Skaters and a Bird Trap* Bruegel has painted the anxiety we all feel about social change. No matter who we are, we often find ourselves caught between the wish for things to remain as they are and the knowledge that they can and will change. Sometimes, we are so caught up in these contradictory feelings that we surrender to a nostalgia that leaves the contradictions unresolved. Other times we may attempt to forget the past and experience growth by moving on to the future, however tenuous it may be.

One reason for the contemporary feeling of the painting is that it allows us to visualize the concept of urbanization. If we understand the city to be an expansive entity (which it was even in Bruegel's time), we can think of it as encroaching upon and upsetting the idyllic, bucolic countryside. Seen this way, neither the skaters nor the birds are "foolish." Rather, both are caught up, almost tragically, in a social process that is beyond their control. The large crow in the upper right corner could well be a "lookout;" the question is whether the bird will know enough to give the warning in sufficient time to alert the other birds, the human skaters, or both.

In the 16th century Flemish provinces in which Bruegel lived and painted, the passing of the rural countryside had only begun. Today, we can hardly miss seeing it. During the past few decades in the United States (as well as Europe) the process of urbanization, perhaps better called "sub-urbanization," has proceeded relentlessly. Literally thousands, perhaps tens of thousands, of small natural ponds that would have allowed for skating have been filled in—or in some cases have even become contaminated sites for dumping waste—as farmland and open range have been converted into housing developments. Animals no longer live in the area; few birds fly there. Around the world, landscapes have changed so

dramatically that we may question whether Bruegel painted a scene based in reality or idealized in his imagination.

Whether because of its aesthetic beauty, underlying complex of meanings, or both, *Winter Landscape with Skaters and a Bird Trap* has long been one of Bruegel's most popular works. One indication of this popularity is that it has been much copied. Bruegel's own son, Pieter Bruegel, The Younger (1564-1637/38), painted many of the copies, of which the painting at the Prado is one. Today, one can see the painting as it was painted in 1565 by Pieter Bruegel, The Elder at the Musees des Beaux-Arts in Brussels, or in various private collections (e.g.. see Plate One.) My enthusiasm for it led me to purchase a copy upon leaving the Prado. It hung for years on the wall of the study in my home. I had spent my childhood in a suburban village, not far from New York City, at a time when there were still woods with paths, ponds and vacant lots that allowed the freedom to play, ride bicycles and sleigh-ride during the winter. Twenty years later, in that village, as well as in the surrounding ones, virtually all of these open spaces had been filled in. Thinking of Bruegel's painting allowed me the nostalgic feeling of re-living childhood memories. Images of it often passed through my mind in the years when I commuted from my home in the suburbs to New York where I worked.

Bruegel's other work that hangs in the Prado, his monumental painting, *Triumph of Death*, is of a very different order. (See Plate 2.) Rather than showing the pain of a dying individual, it explores the meaning of death for the human community as a whole. Death is depicted as if it were in tension with life. A cross-section of the dead engages in battle with a cross-section of the living. This complex, detailed painting does nothing less than to integrate two contrasting medieval concepts of death. One is the pessimistic triumph of death. Armies of skeletons fight in phalanxes and win as they overwhelm large numbers of non-descript human beings. From the small scene in the lower right hand corner we

can infer that death overtakes everyone, even the gambler who stands by his table and the two lovers, one of whom simply just continues to play the lute.

The contrasting concept is the dance of death, in which people dance with, defy or even dodge the death that is dealt out by the executioner as he wields his

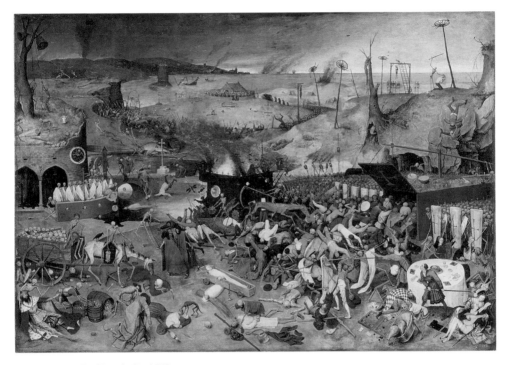

Plate 2: *Triumph of Death,* Ca. 1562
Oil on panel, 46 x 63 3/4 in
Museo del Prado
Madrid

authority. Here one sees the machinery or technology of death, in the depiction of poles with wheels atop them (used to display in public the bodies of those executed, so that others would be deterred from committing crime), and the horse-drawn cart filled with dead bodies (used both for those victimized by famine and plague and by those put to death for having the "wrong" religious beliefs).

Stylistically, this painting has both details of worldly realism, e.g., the figures

of the gambler and lovers and the poles topped with wheels, and grotesques, such as the very anemic horse ridden by the skeleton drawing a cart. Upon reflection, we realize that death is never completely separate from life. The cart of bodies seen on the lower left, drawn by a skeleton seated on an emaciated horse, graphically portrays the message that even the dead need to bury the dead.

My first thought about this vividly realistic/grotesque portrayal of the social reality of death was that it should be appreciated in the context of the times in which Bruegel lived and painted. After all, Europe was wracked by famines in the 13th century and plagues in the 14th century. The latter were particularly devastating because the reasons for them were very poorly understood, and because they affected a cross-section of medieval society: rich/poor, royalty/ commoners, old/young, priests/laity and farmers/merchants/craftsmen/soldiers could all fall victims to the plague. So general were these public health disasters that scholars estimate that somewhere between one-quarter and one-half of the total population of Europe died during the 14th century alone. Although fear of famine declined after the disastrous 13th century, the fear of plagues would last for centuries thereafter.

By comparison, in our scientific 21st century we are likely to believe that advances in agriculture have all but eliminated the possibility of mass starvation, and that medical research either has eliminated or will soon eliminate the possibility of mass death from plague. But the social reality of mass death is by no means so simple. In recent years there have been continuing reports of cases of diseases such as smallpox, tuberculosis and polio, once thought to have been eliminated, as well as emerging new diseases of possibly epidemic proportion: AIDS, SARS, Avian Flu, and Mad Cow disease, for instance. Moreover, our own creations of nuclear and biological weapons, coupled with our inability to entirely prevent their use, could easily wreak destruction comparable to, if not worse than, the famines

and plagues of the Middle Ages. Natural disasters such as the Asian tsunami of 2004 can still strike suddenly, killing hundreds of thousands in a few hours. On September 11, 2001, more than 2,500 people died without warning in minutes, from a surprise, terrorist attack on the World Trade Center in New York City. Since the Holocaust of World War II, the attempted systematic extermination of whole groups of people continues to this day. In this light, Bruegel's powerful painting provides a most sobering reminder that our social life, with its ever-present threat of mass destruction, continues to be a battle of the living versus the dead.

Given the serious, indeed somber, nature of this powerful painting, I was surprised to learn that a copy of it turned up in the 1970's, hanging in the bedroom of a private home in Cleveland, Ohio. Actually the copy was dated 1626, and was probably painted by Bruegel's older son (also named Pieter and referred to as Pieter, The Younger). It is not known for sure how it was obtained, but it appears that the person in whose home it hung acquired the painting in the late 1940's. Reportedly, it was the only painting the person had ever acquired, although he also was interested in contemporary sculpture. The story emerged that he had been an American soldier during World War II, and remained in Europe after the war to do a "grand tour" of cultural centers. Perhaps he was attracted to the painting because he had seen death and destruction first-hand. Perhaps there was a morose streak in his personality. Perhaps he saw *hope* amidst the strife. Perhaps he felt that our earlier reading—that death overtakes even gamblers and lovers—should be switched around to suggest that gambling and love can and should continue, even in the face of death. Perhaps it was the sea in the background or the city on the horizon's center that appeared to offer ways out of, or ways of postponing, the triumph of death. Perhaps its intrigue was that the man, dressed in red, standing by the table and appearing to be drawing a sword, is actually defying death because he is not "ready" to die. Or perhaps the person was, like us, simply fascinated

by the multiple meanings that lurk beneath the surface of this powerful, dynamic painting.

In *Winter Landscape with Skaters and a Bird Trap* and *Triumph of Death* I began to see the "something more" that is so characteristic of Bruegel paintings. Birds are not simply birds; they are symbols that connote other meanings that connect to the human situation. The dance of death is, at the same time, a battle for life. Many paintings have more than one meaning, so that the more you look, the more you see. Bruegel paints social complexity. Later on I would learn that Edward Snow spent over 15 years exploring the meanings of play put forth in one Bruegel painting, his well-known *Children's Games;* and that Michael Francis Gibson examined *The Way to Calvary* and discovered, among other things, imagery that predated the Christian era alongside imagery offering a social critique of the secular world in which Bruegel lived—all in addition to the basic message of suffering portrayed in the painting! In this sense, Bruegel's genius in art parallels Shakespeare's genius in literature; both draw us into the transcendental and the extraordinary. The paintings are anything but period pieces. If we agree with Harold Bloom that Shakespeare "invented" us as humans, then we can, by the same token, argue that Bruegel "created" our culture, through the manner in which he depicted humans acting in the context of their natural environment.

Bruegel's immense capacity for giving us "something more" was noted early on in a famous eulogy delivered in 1573 (four years after his death) by Abraham Ortels, his oldest, closest friend, and a first rate geographer/ cartographer noted for being the first person to produce the modern atlas: "Pieter Bruegel painted many things that cannot be painted. ...In all his work there is always more matter for reflection than there is painting."

Discovering the riddle of the "something more" is itself a fascinating challenge. I have found that virtually all of Bruegel's paintings give something more, but that

the something more varies greatly from painting to painting. Moreover, like Snow and Gibson, I also have found that the more I looked at any one painting, the more I would see.

One key to understanding the riddle of the something more is to think that Bruegel, in painting the complex meanings that underlie the surface realities of social life, was actually painting its "soul." How to paint the soul of anything is a problem that has long bedeviled painters. In his insightful short story, "The Unknown Masterpiece," Honore de Balzac, the French novelist, conjures up a discussion between two artists seeking to solve what might appear to be a straightforward problem: how to paint a nude. Porbus, the student, notes that after studying the model's breast, "…certain effects which are true in nature cease to be lifelike on canvas." But Frenhofer, the older artist who has learned the secrets of the masters, replies:

> It's not the mission of art to copy nature, but to express it! Remember, artists aren't mere imitators, they're poets! …It's our task to seize the physiognomy, the spirit, the soul of our models, whether objects or living beings. …Beauty is something difficult and austere which can't be captured that way; you must bide your time, lie in wait, seize it, and hug it close with all your might in order to make it yield.

This is, I think, exactly what must be said for Bruegel's approach to painting our social life. The "soul" of *Winter Landscape with Skaters and a Bird Trap* is the spirit of living on the edge or skating on thin ice, not knowing what will happen next. The "soul" of *Triumph of Death* is that life and death are continually flirting, dancing, struggling and battling with one another. One can feel morose about the inevitability of death, but one can also dance with joy to celebrate life as it is here and now.

Thinking of social entities as having a soul led me to see the city of Madrid differently. When I arrived there in June 1972, Madrid appeared to be a city just emerging from a long, depressing period of civil war that began in the 1930's and was followed by years of tension associated with the fascist dictatorship of Generalissimo Francisco Franco. Being there gave me the feeling of stepping back in time. The cars were older. The buildings were much in need of paint and repair. Many tasks now automated in the United States and elsewhere were done by manual labor, such as the streets being swept with hand-pushed brooms. Goods were cheap; a satisfactory dinner could be had for only a few American dollars. In the villages barely 20 miles from the center of the city, life was very traditional. Driving through the countryside in mid-morning, one would see women lined by at the village well doing wash by hand. In the fields men used ox-pulled, single-blade plows to cultivate the land. In this distinctly pre-modern world it felt as if little had changed since ancient times.

Then I realized that if I took Bruegel's perspective, I could see Madrid in a deeper, more meaningful way. The realization came at the bullfight. I went with skepticism. The bullfight had always seemed to me to be a somewhat morbid, dangerous affair that was little more than the ceremonial killing of a bull. Yet, it was in the bullfight that one could feel the pulse and beat of Madrid, indeed of Spain. The rather sedate city came to life for the Saturday afternoon to evening fight. Conducted in its own arena, the Plaza de Toros, it was clearly the main show in town. The event comprised not one but seven fights, each of which was the reenactment of the ancient ritual of man versus beast. Nor were the fights simply a matter of the matador killing the bull. There was a pecking order of assistants who served to prepare the bull for the matador: *banderilleros* who enraged the bull by stabbing it with darts, *picadors* who jabbed it with lances, and *toreros* who distracted it by waving red flags. The whole scene was social ritual at its best.

Each of the seven fights had a unique dynamic. It was in the bullfight that I saw Spanish culture performed as ritual, and the vibrancy of a society that would later emerge from decades of lethargy.

In short, taking a cue from Bruegel, I saw that the bullfight and everything it symbolized revealed that the city of Madrid was, in fact, something more than the drab social conditions had made it appear. Madrid had a unique feeling or a soul that differed sharply from that of other European and American cities. Moreover, while the soul was of ancient origins, it also animated the culture of the present day.

I left Madrid feeling that Pieter Bruegel was my favorite artist. His paintings seemed bigger than life. It was exciting to find the "something more" in them that went beyond the scenes that were depicted. With this something more, Bruegel's paintings embodied an aesthetic, indeed, a way of thinking that gave insight into both his times and ours. Little did I realize at the time that my lifetime of discovery through the close examination of the art of Pieter Bruegel had only begun. There would be more, indeed, much, much more. But it would not be until 1997, with a trip to Vienna, that I would actually see other Bruegel works first-hand, and begin to fully understand the enormous scope of his art.

Chapter 2
Vienna, 1997

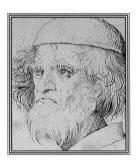

he art historians H.W. and Anthony F. Janson call Pieter Bruegel "the only genius among Netherlandish painters." If we take genius to mean the creation of highly original work that breaks through established categories of thought, some would say that Bruegel's painting genius lies in its superb mastery of landscape detail. Others might focus on the rich depictions of people's character, which seem to capture the essence of the Flemish folk as we have come to think of them. Still others would call attention to the creative use of color, which always seems to portray the inner meaning of the subject of the painting. While all of these may be true, to me the genius of Pieter Bruegel's painting lies in the manner in which it incorporates a certain "something more."

The single best place in the world to appreciate the scope of Pieter Bruegel's genius at painting is the world-renowned Bruegel Room at the Kunsthistorisches (Art History) Museum in Vienna. Although it houses "only" 12 of Bruegel's 36 major paintings, they are arguably among his best. Each one embraces its own "something more," so that the paintings portray the aesthetic of subjects as diverse as the seasonality of our lives, the universal propensity for play, a wedding

ceremony, crucifixion, and even suicide. The images in the paintings range from suffering to bliss, from cynicism to belief, from gaiety to despair. Moreover, they also embrace a variety of painting styles. For many, the Bruegel Room has an almost magical effect. Confirmed lovers of Bruegel go there again and again. So popular has the room become that, on many days, it needs to be seen at off-hours to avoid the crowds.

There is a certain irony that the city of Vienna and the art of Pieter Bruegel are inextricably linked. So far as we know, with the exception of a two-year travel excursion that took him to Rome and Naples, Bruegel's entire professional life was spent in Antwerp and Brussels. The story of how the major part of Bruegel's work came to be in Vienna today is, in itself, a unique tale of power and wealth.

With origins that date back to the Iron Age, Vienna was first chartered as a city in 1221. Of importance to our tale is that it emerged as the center of an empire during the 1500's, when the Austrian Habsburgs made it their seat of power. This came about in 1526 (not long after Bruegel was born), when Archduke Ferdinand of Austria was elected king of Bohemia as well as king of Hungary. The Austrian line of the House of Habsburg was to rule an empire that would keep Austria, Bohemia and Hungary under single rule until 1918, the end of World War I. The empire would be characterized by disparities of economic condition, social habits and standards of culture that ranged from a very cosmopolitan and cultured Vienna to the backward hamlets of the Ukrainian east and to the new world "frontiers" of Mexico and South America. The Habsburg Empire was also the world's first empire with holdings on which the sun never set, and the place from which the largest body of immigrants to the United States, in the early 20th century, would come. At the same time, it was an empire whose severe rule—in the name of the Counter Reformation of the Roman Catholic Church—would see Protestants rigorously persecuted to the point of execution, and their property confiscated in

order to compel them to recant their beliefs.

Fortunately for Western culture, the empire was more than the raw power of military might. The Habsburg's military prowess was matched by an equally passionate pursuit of learning and the arts. Historians depict Maximilian II (1527-76), Ferdinand's son, as a true Renaissance king, with a broad intellectual curiosity that combined the rediscovered learning of classical antiquity and a contemporary concern for observation and comparative analysis. His particular interest lay in botany, and he sponsored the work of botanists who made major advances in plant identification and classification.

The Habsburg who would make a difference to the world of the arts, however, was Rudolf II (1552-1612), son of Maximilian and grandson of Ferdinand. Rudolf shared his father's wide intellectual interests, except that his real passion was to amass an art collection. Following the practice of the day, he set up a royal residence in Prague, separate from that of his father in Vienna. Once there, Rudolf followed his artistic passions entirely, virtually ignoring the affairs of state. He brought craftsmen, artisans and artists from all over Europe to work at his castle. His art collection grew to be extensive and, at the same time, competitive with that of his Spanish Habsburg cousin, Philip II. Considered by some to be a "mad" emperor, Rudolf often withdrew to his laboratory or library away from everyone. In 1606 his younger brother, Matthias, usurped Rudolf's right to the throne upon the death of their father. So it was that Rudolf never came to exercise military or political power. But the move left Rudolf completely free to follow his artistic passions, and it was for his work in the field of art that he would long be remembered.

Rudolf must have had a passion for Bruegel's art, for he was the first avid non-Flemish collector of his paintings. Bruegel's art had been appreciated during his own lifetime (when Bruegel died in 1569, Rudolf was still young), and it had apparently enjoyed the attention of at least three patrons: one a bishop of the

Roman Catholic Church and the other two wealthy businessmen of the day. But it was Rudolf who assembled 12 Bruegel paintings for his personal collection, the largest number in one place. Some were inherited from his brother Archduke Ernst, who was governor of the territory of the Netherlands for several years, while others were purchased on the open market. By comparison, Rudolf's Habsburg cousin, Philip II (1527-98)—a Spanish king who exercised power so ruthlessly it led to an 80 year war in the Flemish provinces, and who also collected great art—came to possess only two Bruegel paintings (the ones that are in Madrid).

Rudolf also had a hand in how the Bruegel paintings were to be displayed. Reportedly, he personally designed the lower floors of the Kunsthistorisches Museum. If so, it seems logical that he would have planned the separate room that featured the 12 magnificent paintings that so capture the essence of Bruegel's art. Today, the Bruegel Room is home to 16 of his paintings. In addition to the 12 by Pieter Bruegel, The Elder, there are four other paintings in his style, including two by his son Pieter, The Younger, one by his son, Jan, and another by a follower who painted in his style. All of the paintings are the ones Rudolf had in his personal collection.

The art in the Bruegel Room is so rich that one hardly knows where to look first. However, if you seek out the "something more" that always lurks beneath the surface of Bruegel paintings, you will begin to see among the 12 paintings several very different approaches that Bruegel took in his portrayals of social life.

SEASONALITY

As one enters the Bruegel Room through the door shown on the right side of Diagram 1 (see page 46), the first three paintings on the long wall to the right are from his seasonal series. (See Plates 3 through 5: *Return of the Hunters* (also called *The Hunters in Snow*), *The Dark Day,* and *The Return of the Herd.*)

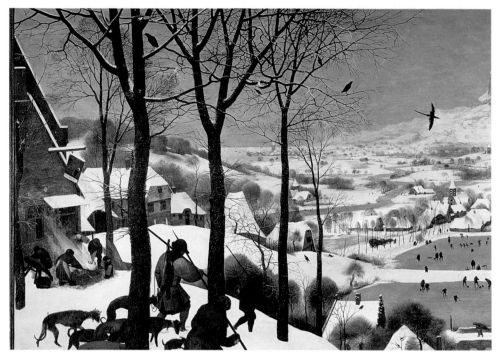

Plate 3: *Return of the Hunters,* 1565
Oil on panel, 46 x 63 3/4 in
Kunsthistorisches Museum
Vienna

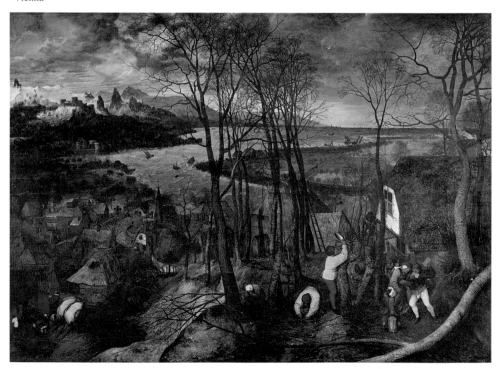

Plate 4: *The Dark Day,* 1565
Oil on panel, 46 1/2 x 64 1/8 in
Kunsthistorisches Museum
Vienna, Austria

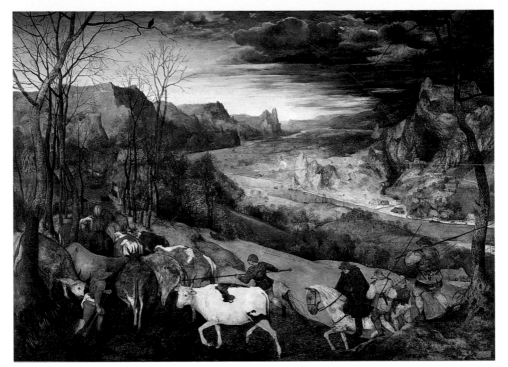

Plate 5: *The Return of the Herd*, 1565
Oil on panel, 46 x 62 5/8 in
Kunsthistorisches Museum
Vienna

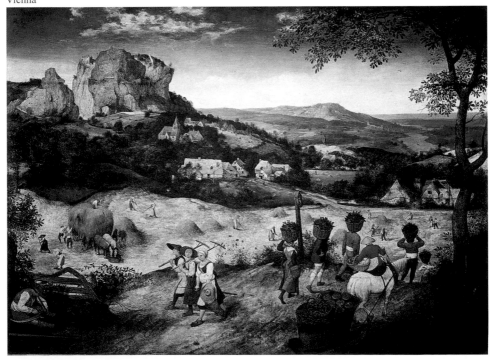

Plate 6: *Haymaking,* 1565
Oil on panel, 46 1/2 x 63 1/4 in
National Gallery, Collection Prince Lobkowitz
Prague

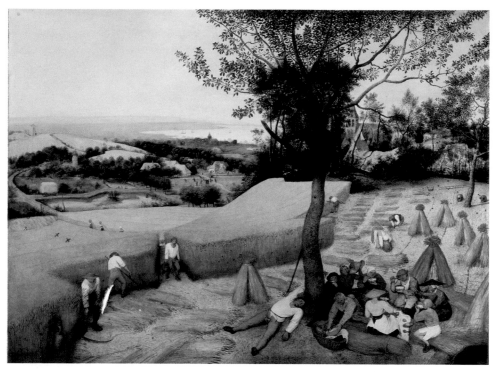

Plate 7: *The Harvesters*, 1565
Oil on panel, 46 1/2 x 63 1/4 in
The Metropolitan Museum of Art, Rogers Fund, 1919 (19.164)

These serene landscapes are among the most beautiful of Pieter Bruegel's paintings. They are also the most straightforward, in that each depicts a scene that is seasonally appropriate. In *Return of the Hunters* we see the starkness of the December/January period of winter. In *The Dark Day* we see the February/March of late winter with peasants busying themselves in selected chores. In *The Return of the Herd* we see an early winter activity that would normally occur during November, of drovers moving cattle.

Although the three are part of a set, there are two other seasonal landscape paintings that are not among those in the Bruegel Room in Vienna, namely, *Haymaking*, representing July, the month during which hay was cut, and *The*

yesterday. It is very easy to forget that the painting was completed more than 450 years ago, and that the world portrayed is idealized and may never have existed as an actual landscape.

If there is starkness in *Return of the Hunters*, the mood conveyed by *The Dark Day* is somber. (See Plate 4.) The color tones are dramatically darker, and there is relatively little contrast between the dark brown and black of the foreground and the gray and black of the background. Identifying with the peasants in the foreground, we kill time by involving ourselves in everyday activities, such as pruning trees, thereby warding off the doldrums of winter.

As the year goes on, Bruegel's aesthetic continues to capture each season to perfection. In July's *Haymaking* an intriguing yellow dominates the foreground of the painting and contrasts to the light blue of the water in the distance. (See Plate 6.) From the two men pitching hay in the middle-left to the three women carrying rakes presumably on their way to work, this pastoral scene conveys the very pulse of the day-to-day heart of agricultural life. A similar statement could be made for *The Harvesters* were it not for the fact that it features the much sharper definition of activities that would be appropriate for harvesting a crop. (See Plate 7.) In *The Harvesters* the work activities are framed by diagonal lines, which mark the places where the hay has already been harvested. Shown in the lower right corner under a shade tree, some of the presents are taking a presumably well-deserved break from hours of labor in the torrid sun. The color contrast between the bright yellow of the yet to be harvested wheat and the dark greenery of the field in the distance serves to reinforce the significance of the activity in which the peasants are involved.

The year ends with *The Return of the Herd*, Bruegel's painting of November. (See Plate 5.) Although November is close in time to December/January, the starkness of winter is not yet full, and the mood of this painting differs sharply from that of *Return of the Hunters*. The colors are the dark golden and gray browns of

autumn; even the white bull that leads the procession has a touch of dark brown on his body. Generally, this painting is much flatter, in the sense that perspective is not dramatically emphasized. To the extent that there is depth, it is created by the curved, lazy diagonals of a river, which begins one-third of the way up on the right side of the painting and then bends so that the painting is balanced. In contrast to *Return of the Hunters*, there are no manmade structures other than a small village on the far side of the river. There is no city in the distance. The diagonal lines are not sharply drawn. They are distinctly less angular. Despite the approaching storm in the upper right corner, *The Return of the Herd* is a much more mellow scene, reflecting the autumn that ends the heat of summer but precedes the coldness of winter.

The five seasonal landscape paintings are superb examples of *realism* in art. Emerging during the Renaissance, *realism* allowed artists to conquer pictorial space and thereby to understand the world in entirely new ways. Probably its single-most innovative quality was the use of *perspective*, or three-dimensional art, to replace *a-spective*, or two-dimensional art. Actually, *realism* in art was not unique to the Renaissance. Like much of Western culture, it dated back to the Greeks and was also used in Roman art. However, its powerful artistic techniques were lost during the Dark Ages, and it took centuries (until the Italian Renaissance of the late 13th century) for artists to look back to the past to rediscover how to portray the three-dimensional reality, in which we live, on a two-dimensional surface.

Employing perspective in order to create the sense of expanse of the countryside, the sheer beauty of these Bruegel landscapes has long been recognized by scholars, writers and lovers of art. It was Aldous Huxley, the early 20th century writer and critic, who called "The Autumn Day" (*The Return of the Herd*) a painting of "most exquisite beauty" and *The Dark Day* "…one of those natural

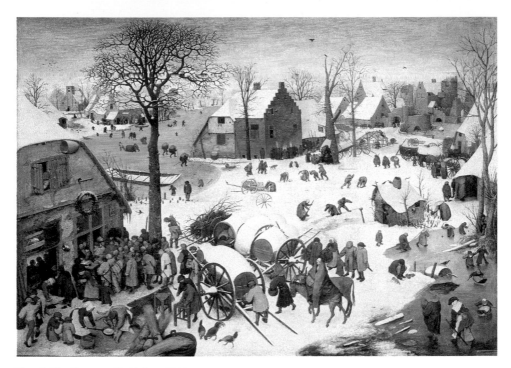

Plate 8: *The Census at Bethlehem*, 1566
Oil on panel, 45 5/8 x 64 3/4 in
Musee d'Art Ancien, Musees Royaux des Beaux-Arts,
Brussels

Plate 9: *The Adoration of Kings in the Snow,* 1567
Oil on panel, 13 3/4 x 21 5/8 in
Collection Oskar Reinhart "Am Romerholz," (1930.2)
Winterthur

dramas of the sky and earth—a conflict between light and darkness." Both, he goes on, are "…intensely poetical, yet somber and not excessively picturesque or romantic." J.B. Priestly, another admirer, captured in words the aesthetics of the *realism* that Bruegel incorporated into his seasonal paintings:

> Here is life, down to the last button, as the painter *knew* it…you are nearly always compelled to look *down* on the scenes, as if you are floating in the air just above them. The people have an elfin look. We are poised on the edge of marvels and miracles. This is not plain realism, then, but a realism merging into the magical.

For me, the enduring fascination of these five paintings is that they are somehow far more than simple landscapes. Bruegel managed to capture the "soul" of the scenery, by depicting each season through very complex use of colors appropriate to each, and through the unique depictions of real people involved in seasonal activities. By capturing its soul, Bruegel managed to portray what we have since come to know as the essence of the agricultural life of the 16th century Flemish countryside. In painting seasonal *realism* down to the last detail, Bruegel may have idealized the seasons, but when we look at this set of paintings as a whole, we are left with the sense that he had a larger purpose in mind, namely, for us to see and feel the complete way of life, that is, the annual cycle of activities that comprised the culture of the 16th century Flemish peasant.

Painting the seasons as he did, Bruegel reflected a medieval view that our lives take place in stages that are seasonally cyclical. While this is obviously the case for an agricultural society, we live today in a society where we often pursue work and leisure activities without care for the seasons, and often even without care for the weather. But we ignore seasonality and weather at our peril. In his book, *The Little Ice Age*, Brian Fagan reminds us that climate made history during the

period of 1300-1850, and that it may do so again, as we cope with the implications of a "warmer greenhouse," in which we watch seasons diminish in their intensity or, perhaps, even disappear. (Fagan's book cover shows another of Bruegel's paintings, *The Census at Bethlehem*, which is thought to be the first depiction of snow in western art.) (See Plate 8; see also Plate 9 for Bruegel's painting of snow actually falling.) Today, we live at further remove from nature and relatively fewer of us are employed in occupations or businesses that are seasonal. With the airplane we can, of course, travel to places that give a sense of climate that differs from the one we have at our home. We fly to get the feel of summer, if it is winter where we live, or the feel of winter, if our home is in a place that is experiencing a heat wave. Although they were painted more than 450 years ago, Bruegel's masterpieces of seasonality allow us to feel seasonality right where we are.

TOPSY-TURVEY WORLDS

Moving beyond the seasonal paintings in which humans are at one with nature, we are thrown into worlds in which the "something more" Bruegel has to offer is of an entirely different order. Paintings 4, 5, 7 and 8 in the Bruegel Room (see Diagram 1) are unique, each in its own way: *Conversion of Saint Paul*, *The Suicide of Saul*, *The Way to Calvary* also known as *Jesus Carrying the Cross*, and *The Tower of Babel.* (See Plates 10 through 13.) (We omit the works of Jan Bruegel, Pieter's other son, and Pieter Bruegel, The Younger).

To be sure, each is a landscape. Each one is beautiful and painted in meticulous detail. But these four landscape scenes are populated with people involved in actions that portray, respectively, a major abnormality of social behavior: conversion through out-of-body experience, the crime of suicide, the punishment of crucifixion, and the inherent chaos of human society. The paintings are replete with tension. The abnormality of subject matter belies the natural

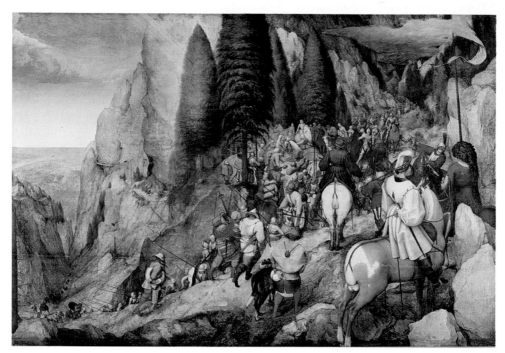

Plate 10: *Conversion of Saint Paul*, 1567
Oil on panel, 42 1/2 x 61 3/8 in
Kunsthistorisches Museum
Vienna

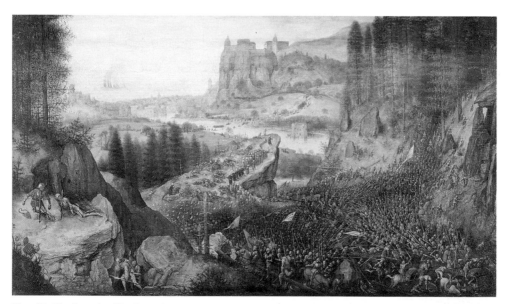

Plate 11: *The Suicide of Saul* , 1562
Oil on panel, 13 1/4 x 21 5/8 in
Kunsthistorisches Museum
Vienna

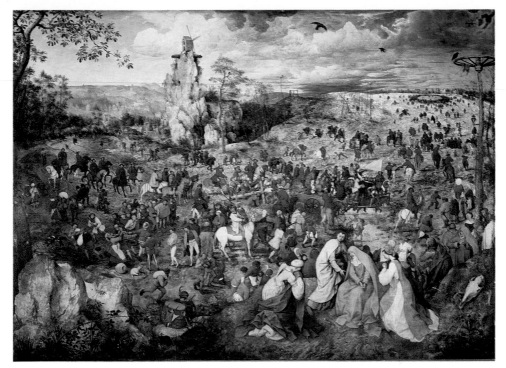

Plate 12: *The Way to Calvary*, 1564
Oil on panel, 48 3/4 x 66 7/8 in
Kunsthistorisches Museum
Vienna

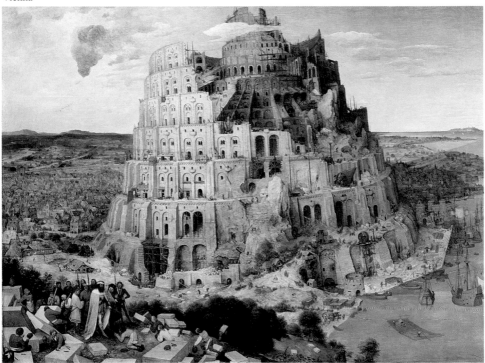

Plate 13: *The Tower of Babel* (Vienna), 1563
Oil on panel, 44 7/8 x 61 in
Kunsthistorisches Museum
Vienna

beauty of the landscape. The world is "topsy-turvy," out of joint, however you want to put it. People are at odds with nature.

Each of the landscape scenes is in the style of Renaissance *realism*—that is, each embraces an idealized conception of reality that is depicted in great realistic detail. To appreciate the detail, look at the mountains in the background of Paul's conversion, and think of the comment of Carl van Mander, Bruegel's early biographer, that after his lengthy trip through the Alps taken years earlier, Bruegel "swallowed all the mountains and rocks and spat them out again, after his return, onto his canvases and panels." Try to count the number of soldiers in Saul's army who would have been witness to his suicide. In *The Way to Calvary* consider the number and types of persons who comprise the horde of people in the scene. They include soldiers carrying out the death sentence by accompanying their prisoners en route; women, including the Virgin Mary, praying in the foreground; a peddler; and even an artist. Some carry out the divine tragedy of the crucifixion. Some mourn it. Some ignore it. The complexity of both the scenery and action in this painting is so great it inspired Michael Francis Gibson to write *The Mill and the Cross*, one of three books to be written about individual Bruegel paintings. Finally, take note of the thousands of workers involved in constructing the Tower of Babel, and Bruegel's detailed attention to the specific techniques of construction. Later research has shown that Bruegel's artistic rendering conforms very closely to the construction techniques of his day, displaying a working knowledge of construction and the particular trades involved in it.

But these paintings take on another level of meaning when we appreciate how the subject matter of each involves very unsocial acts that clash, sometimes violently, with what we consider to be the natural order of things. In *Conversion of Saint Paul*, which follows the New Testament story as told in *Acts 9: verses 2-9*, we see Paul with his army on the way to Damascus to persecute Christians

struck down, through what he saw as an act of God, blinded and made unable to drink for three days. In *The Suicide of Saul* we see a King Saul, one who would have lived hundreds of years earlier during Old Testament times, committing the criminal act of suicide, in order to save face, because he embarked foolishly on a disastrous campaign against the Philistines, in which his very own sons had perished. Following many commentators, we could take this a step further to argue that Saul's end in suicide was "…caused by his disobedience to God's voice" (*1 Samuel 28: verse 18*). We see in *The Way to Calvary* the collective violence of the crown that is putting the innocent Son of God to death. Finally, in *The Tower of Babel*, depicted in the lower left is a vain king thought to be Nimrod, a direct descendant of Noah, punished because he had the temerity to build a tower to the heavens so that he could be God.

Each of these paintings also involves the technique employed by many *Mannerist* painters, of hiding the main character so deeply into the painting that he or she is difficult or almost impossible to find. The purpose of this technique is to compel the viewer to look at the painting actively so as to engage it. Of the main characters in these paintings, Paul in *Conversion of Saint Paul* is perhaps the most readily visible, although most of us find it helpful to know in advance that he is the dark gray figure lying on the ground near the middle of the painting. Although commander of the army in *The Suicide of Saul*, the Old Testament Saul is off-center, on the lower left, accompanied by only one other soldier, probably an armor-bearer; the off-center placement reflects the moral ambiguity of his suicide. Hiding the main character greatly intensifies the drama in *The Way to Calvary*. Only with intense scrutiny do you come to realize, as you might perhaps have expected, that the cross is placed literally in the dead center of the sea of humanity, which in turn is in the dead center of the painting. Look further to discover the man borne down by its weight. Finally, in *The Tower of Babel* the builder of the

adults, even if many of the particular games that are depicted are obsolete today.

Fight between Carnival and Lent demonstrates how Bruegel uses abstracted realism to depict turmoil that can be either social or personal. (See Plate 15.) Two points stand out in this very busy scene. One is that the painting is packed with various "skirmishes" that make up the larger battle between the materialism of the carnival and the spiritualism of Lent. In fact, it is so jammed full that there is less empty space in this painting than in *Children's Games*. The result is that the turmoil depicted in the painting is heightened; there is no place to go for relief. The second distortion of perspective, one we may not realize until we stop to think about it, is that Carnival and Lent do not coincide in time. Although the gap is short, Carnival precedes Lent. Even today many people celebrate "the last chance to sin" of Mardi Gras before engaging in the spiritual renewal of Lent. By playing with time and presenting Carnival and Lent as if they come together, Bruegel gives artistic expression to a conflict that lies within each of us. Should we give in to our materialistic desires or should we abstain and seek spiritual purity, fulfilling social obligation or for some other reason. This very basic conflict is one we both feel as individuals and that finds expression in our collective social life.

Bruegel has one more painting of "abstracted realism," his artistic expression of the concept of culture, *The Netherlandish Proverbs*, which hangs in Berlin. (See Chapter 5: From San Diego to Prague.)

GENRE PAINTING

Continuing through the Bruegel Room at the Kunsthistorisches Museum, we omit the two paintings that are "in Bruegel's style" and probably the works of his sons. (Numbers 11 and 12 in Diagram 1 on page 46.) This leaves us with another two paintings for which Bruegel is also well known, namely, *Peasants' Dance* and *The Peasants' Wedding* (also known as *The Wedding Banquet*, each of which is a

genre painting (see Plates 16 and 17) plus another titled *The Poacher* (also known as *Peasant and Bird Nester.*) (See Plate 19.)

The realism of genre painting differs from that of the idealized, seasonally thematic landscapes we saw earlier. Its aim is, simply put, to depict scenes or events as they are from every day life. If thematic landscapes endeavor to provide "the big picture" from a distance, genre paintings are action snapshots taken much closer. Even more than in the thematic landscapes, the people in genre paintings appear to act naturally. Indeed, the whole emphasis of the painting is on the action depicted. A good genre painting is so realistic that we may well feel invited to join in whatever is going on.

So potent was Bruegel's ability to paint genre works that, even though he painted only three of them (the third, *The Wedding Dance*, hangs in Detroit, Michigan—see Plate 18), he has long been regarded as "the inventor of genre painting." Completed between 1566 and 1568, the very years he was painting the superb idealized seasonal landscapes discussed earlier, the three peasant scenes are also fascinating works of art in that they portray significant aspects of the life of the Flemish peasant.

One key reason for the dynamic quality of these paintings is that they are based on Bruegel's studied observations of everyday life. Although we know little of Bruegel's personal life, his early biographer, Carl van Mander, wrote that Bruegel and a friend were known to have taken trips to the countryside to see peasants and attend their weddings and fairs. The two went so far as to dress like peasants and act as if they were relatives of acquaintances of those involved in the festivities. In so doing, they were among the first, if not the first, intellectuals in Europe to assume the perspective of observers of society; today we would call them "participant observers." According to van Mander, Bruegel relished the role and observed much.

Here Bruegel delighted in observing the manners of the peasants in eating, drinking, dancing, jumping, making love, and engaging in various drolleries, all of which he knew how to copy in color very comically and skillfully, and equally well with water-color and oils; for he was exceptionally skilled in both processes. He knew well the characteristics of the peasant men and women of the Kampine and elsewhere. He knows how to dress them naturally and how to portray their rural, uncouth bearing while dancing, walking, standing, or moving in different ways. He was astonishingly sure of his composition and drew most ably and beautifully with the pen. He made many little sketches from nature.

None of Bruegel's genre paintings is built around a moral or story. Nor is any violence, social abnormality or abstraction portrayed. Rather, each is densely packed with people interacting with one another. The horizon line, so important in his landscapes, is close to the top of the painting and of little interest. The visual effect of space is created by the enormous wealth of color that is painted into the scenes. The charm of these paintings lies in the fact that they are all action. Each one displays so much activity that you are left with the feeling that you are part of what must have been a very vibrant, earthy social reality.

Given these three paintings alone, is it any wonder that Aldous Huxley could write that Bruegel is "…perfectly qualified to be the natural historian of the Flemish folk?" As he puts it,

(Bruegel) exhibited them mostly in those moments of orgiastic gaiety with which they temper the laborious monotony of their daily lives; eating enormously, uncouthly dancing, indulging in their peculiarly Flemish scatological wagery.

"The Wedding Feast" and "The Peasants Dance" ...are superb examples of this
anthropological type of painting.

In these three genre paintings Bruegel stands in marked contrast both to painters
of his day and many others who followed. In Paulo Veronese's *Marriage at Cana*,
painted in 1562/63, about the same time as the Bruegel's pieces, the nobles are
portrayed as so posed and idealized that they do not even need to put a spoon into
their mouths. By contrast, Bruegel's peasants are "real people" who eat, drink, and
dance to music at weddings.

With their liveliness, is it any wonder Bruegel's genre paintings continue to
fascinate us? To me, the one that is most up-to-date is *The Peasants' Wedding*. (See
Plate 17.) As you look at it, you become so focused on the eating, drinking, and
live music that you cannot help but feel like joining in the festivities. The painting
always makes me think how little things have changed. Today, weddings are still
very much part of our social lives (even if we conveniently ignore the statistic that
one of every two marriages eventually ends in divorce), because they are occasions
that bring relatives and friends joyously together to celebrate individuals forming
ties with one another.

At the risk of contradicting our earlier comments about the nature of genre
painting, a second look at *The Peasants' Wedding* shows that even Bruegel's
genre pieces may have the certain "something more" in them. In this painting,
note the bride. Clearly she appears to be in a world of her own; indeed, she is
without the groom. In portraying the bride in this manner, Bruegel is distinctly the
anthropologist. From this perspective, we can best understand the painting if we
know that, in Bruegel's times, the groom was not admitted at all to the wedding
banquet, because he was expected to serve the bride and her family. Moreover,
some observers have gone further to argue that Bruegel portrayed this scene

from a moral viewpoint, emphasizing the domination of gluttony, a perversion of the sacred rite of marriage exemplified in Christ's miracle of turning water into wine at the marriage feast of Cana. Another "something more" in this painting is the man at the far right, to whom the hooded Franciscan monk is talking. A closer look shows him to be dressed differently than the other guests. Actually, he appears to be rather more a gentleman than a peasant. Some believe the man to be Bruegel, who painted himself into the picture. Whether or not this is so, he is clearly a participant observer—involved in the scene around him but in a rather detached manner. Once we realize this, we know that we can gain another perspective, by entering the scene through his eyes, as if we were seated in a corner vivaciously celebrating the joyous event (perhaps without even knowing the couple involved)—so similar to and yet so different from a wedding we might attend today.

It is an irony of art history that while Bruegel's genre painting exerted a tremendous influence on later artists, especially those of the 17th century, his work as a genre painter did little to enhance his reputation as an artist, and actually may have detracted from it. This is because traditionally in the world of art

> Subjects suitable for painting were arranged in a hierarchy of superiority. History painting, together with religious and mythological subjects, were considered the highest, with portraits, landscape, still life and genre painting lower down the scale. The first three were thought to be superior because they were morally uplifting. History painting, in particular was supposed to be about heroism and especially heroic death, preferable in classical times.

It should also be said that genre painting in the style of Bruegel went beyond the simple depiction of quaint peasant scenes. In looking at these three masterpieces,

one must bear in mind that peasant life in the mid 1500's could well be described in the words of the philosopher Thomas Hobbes as "nasty, poor, brutish and short." Moreover, the rhythm of peasant life was dictated by an annualized cycle that repeated itself year after year. If Bruegel idealized peasant life in his seasonal paintings, he naturalized it in his genre paintings. For it is in these paintings that the peasants show no signs of despair over the quality of their lives. To the contrary, they celebrate life despite its hardships. They feast. They drink. They dance. They make music. They kiss. They make love.

A MORAL/MYTHIC PAINTING

The remaining painting in the Bruegel Room, *The Poacher* (see Plate 19) seems, at first sight, to be another genre scene. The action is very much "up front," the figures are not posed, and the rendering of landscape does not quite seem to be the point. On second thought, however, the whole painting is very much an enigma; indeed, so much of an enigma that scholars have long debated the meaning of this work. Most believe it to be a depiction of a 16th century Netherlandish proverb played out by the two figures in the painting: "He who knows where the nest is has the knowledge; he who robs it has the nest." But if even knowing this leaves us in doubt, we are not alone.

> The puzzle of the gesture with which the young man relates to the bird nester has not yet been solved. Whether he is already sure of his prey, which lies besides him on the ground in a sack or whether he only 'knows' the nest, as in the proverb, while the other is possessing it, cannot be decided. Either way, he is on the point of falling into the brook.

In short, we are left in a conundrum: who has the knowledge and who is the

robber? The gesture of finger pointing clarifies nothing. Here is genre with a spin, that is, genre that makes us think.

Thoughts about the conundrum depicted in *The Poacher* resonate today when we consider complex court cases such as those of Enron and WorldCom that epitomize corporate and white-collar crime. They revolve around business dealings in which people exchange large amounts of money. While many exchanges of money are perfectly legal, some are intentionally or inadvertently criminal, whether the crime is bribery, larceny or fraud. The exchanges often take place in far remove from public view, and the appearance of the meaning of the exchange may be sharply at variance with its reality. When the dealings are criminal, the questions can very quickly become quite complex: How/when/where can or should the crime be made public? Who knew what? When did she/he/they know it? Does insider knowledge of the crime implicate the person who knew about it whether or not she or he participated in it? The answers can be very elusive, anything but simple. The situations may be totally different but our moral dilemma differs little from that of Bruegel's peasant. No wonder the painting continues to fascinate.

In putting us into a conundrum, *The Poacher* serves to illustrate yet another major type of Bruegel's painting—one I would call *moral/mythic*. The purpose of this type of painting is to penetrate the surface of the scene that is portrayed. Thus, *The Poacher*, a case in point, is no simple country scene. However beautiful it may first appear, it is not a quaint genre painting. The characters are by no means simple-minded country bumpkins casually at play with one another. Rather, the painting throws us into a set of moral questions that give us pause to think, just as it did for people of Bruegel's day. *The Poacher* is by no means the only painting into which Bruegel incorporated moral questions and meanings of myths. Indeed, we shall see many more as we proceed to look at his other works.

I left Vienna feeling very moved by Bruegel's paintings. In so many ways they seemed larger than life. Certainly they conveyed what seemed to be the essence of the social life of Bruegel's time. Simultaneously, they always seemed to embrace a "something more." Scenes came alive in such a way that they said something about the present—about the manner in which we feel seasonality in our 21st century world, about how out of the ordinary experiences disturb, if not destroy the sense of order we like to expect, about the eternality of play, about the ever-present conflict of material versus spiritual sides of our selves and about moral enigmas that remain intractable. I was captivated by Bruegel's use of the paintbrush to convey perspectives on social realities as varied as idealized conceptions of seasonality, as forms of ugliness that we may not want to acknowledge, as critiques of political power, and as confrontations with long-standing, problematic moral dilemmas.

I resolved to seek out and experience more of the worlds created in Bruegel's paintings, by traveling to the cities where he lived and worked, and to other places where his work hangs today in galleries or museums. Uncertain where all of this would take me, I felt my life becoming vastly richer through looking at Bruegel's paintings, thinking about the "something more" in them, and asking myself why they still seemed to make so much sense for today's world. My next destination was Antwerp and Brussels—cities in which Bruegel had lived and worked.

Diagram 1: Bruegel Room at the Kunsthistorisches Museum

```
[      5       4       3       2       1     ]
[ 6                                     16 ]
[
[
[                                          ]
[ 7                                     15 ]
[                                          ]
[ 8                                     14 ]
[                                          ]
[    9      10         11     12      13    ]
```

(1) Return of the Hunters (Plate 3)

(2) The Dark Day (Plate 4)

(3) The Return of the Herd (Plate 5)

(4) Conversion of Saint Paul (Plate 10)

(5) The Suicide of Saul (Plate 11)

(6) A Visit to the Doctor (Jan Bruegel)

(7) The Way to Calvary (Plate 12)

(8) The Tower of Babel (Plate 13)

(9) Children's Games (Plate 14)

(10) Fight between Carnival and Lent (Plate 15)

(11) Feast of St. Martin (Pieter Bruegel, The Younger)

(12) Massacre of Innocents (After Bruegel)

(13) The Poacher (Plate 19)

(14) Peasants' Dance (Plate 16)

(15) Peasants' Wedding (Plate 17)

(16) Winter Landscape with Birdtrap (by Pieter Bruegel, The

Younger) (See Plate 1 and comments in Chapter 1)

Chapter 3
Antwerp and Brussels: 1998

A big paradox surrounding Pieter Bruegel, The Elder is that while his art tells us so much about the times in which he lived, we know relatively little about his own life. Reportedly he was born in a small town near the modern day city of Breda (about 50 miles north of Brussels), but the town no longer exists. We know that he died in 1569, but are uncertain about the year of his birth, which was sometime between 1520 and 1525. There are some records reporting his journey to Italy between 1552 and 1554, but the exact dates of his coming and going are unclear. Nevertheless, it can be said with some confidence that Bruegel lived in Antwerp between 1548 and 1563 (except for the sojourn to Italy), where he worked as an illustrator of prints and completed some of his major paintings. Also, it was in Antwerp that he was registered as a master painter in the Artist's Guild for the years 1550 and 1551. Finally, we know that he spent the very productive last six years of his life, from 1563-1569, in Brussels. Twenty-seven of his 36 major paintings were completed there.

I went to Antwerp and Brussels full of questions about Bruegel and his art. Did he capture the imagery and "soul" of these cities, just as he had caught that

of the countryside? Were there social meanings or messages embodied in the "something more" of his art that went beyond those I had seen in Madrid or Vienna? Was it possible to shed more light on the intriguing questions of how and why his paintings, created more than 450 years ago, seem so fresh, so relevant to us today?

Compared to the little we know about Bruegel's life, we know quite a bit about the places and the times in which he lived. Antwerp of his day was a very dynamic center of trade, linked to what was a developing world economy of the 16th century. During those years, it was in the second of three phases of expansion, attributable both to the prosperity from trade with nearby Spain and the silver that came from the recently discovered Americas. With the influx of silver, Antwerp quickly became not only a banking center but also a major player in the trade in wool, which had formerly been conducted in Bruges, as well as the trade in salt, alum, dried fruits, cooking oil and a variety of other products. Although much of the trade came to an abrupt end with the bankruptcy of the Spanish state in 1557, the Antwerp of Bruegel's day saw tremendous growth. Its estimated population of between 44,000 and 49,000 in 1500 more than doubled, to about 100,000, in 1568, and the number of houses rose from 6,800 to 13,000, as building proceeded apace. As is often the case, "Luxury, capital, industrial activity and culture all blossomed together." One indicator of its prosperity was that Antwerp had become a magnet for painters. By 1560 there were an estimated 360 painters in the city. Given the population of 89,000 at the time, this would mean that there was roughly one painter for every 250 citizens—a very considerable number!

The city of Antwerp was of great importance in Bruegel's life. It was in Antwerp that he appears to have achieved artistic and commercial success, while employed and trained by Pieter Coecks van Aelst, a leading Flemish artist whose daughter he would later marry. The success was based on his distinctive

craftsmanship in line drawing. Today there are 61 known drawings, some of which were done in collaboration with other artists. Nevertheless, it is in these drawings that one can see Bruegel's unique style, with its incorporation of social themes and meticulous attention to detail. Some of the drawings are fantastic or allegorical in the manner of the famous Hieronymous Bosch (1450-1516), and parody the crass commercialism of the day; for example, his *Big Fish Eat Little Fish* of 1556. Others were realistic landscapes such as *Alpine Landscape* of 1553. Still others incorporate Flemish proverbs expressed in the style of the genre painting we saw in Vienna. Of particular interest is *The Beekeepers*, a print that utilizes the same proverb as his enigmatic painting, *The Poacher*, namely, "He who knows where the nest is has the knowledge/he who robs it has the nest." (See Chapter 2)

Antwerp was also of importance to Bruegel because it was home to Nicolaes Jongelinck, a prominent merchant regarded by art historians as "the most avid contemporary collector of Bruegel's work." At one point Jongelinck owned no fewer than 16 of Bruegel's paintings including his famous *The Tower of Babel* and *The Way to Calvary*—more paintings than Rudolf II would ever come to own. The five paintings (perhaps even the elusive sixth) of the seasons are thought to have decorated a room in his country villa. Sometime around 1565 (prior to Bruegel's death) the city of Antwerp assumed ownership of these paintings, because Jongelinck had posted them as security for a loan on which his friend, Daniel de Bruyne, defaulted. They subsequently "fell into" the hands of the governor of the Netherlands, Archduke Ernst, who ruled the country from 1593 to 1595, and then went to Rudolf II, the Habsburg who was enamored of Bruegel's art. In any event, Jongelinck's intense interest in and support of Bruegel's art suggest that the dynamic commerce of Antwerp provided a context in which Bruegel's art could flourish and find a market. This meant that, unlike much art of later centuries, the value of Bruegel's paintings was recognized in his own lifetime. Jongelinck

was an early patron who was neither of the church nor of the nobility, and it is noteworthy that many of the paintings he owned—especially the ones now in the Bruegel Room of the Kunsthistorisches Museum in Vienna—were works that dealt with secular subjects and embodied the essence of the Renaissance realism for which Bruegel is so well known.

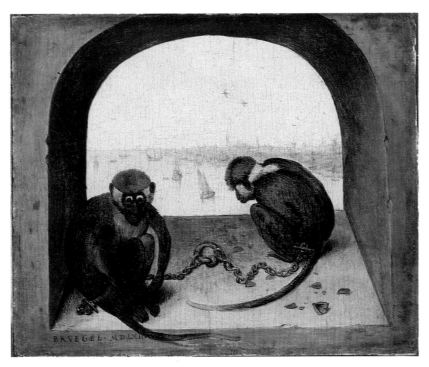

Plate 20: *Two Chained Monkeys*, 1562
Oil on panel, 7 7/8 x 9 in
Gemaldegalerie, Staatliche Museen zu Berlin, Inv. 2077
Berlin

Although neither painting is hanging in the city today, Bruegel captured the essence of Antwerp so vividly in two of his paintings that one might think they had been painted only recently. One is *The Tower of Babel*, in Vienna, and the other is *Two Chained Monkeys*, which is in Berlin's Staatliche Museum. (See Plates 13 and 20.)

Antwerp is an integral part of the background scenery of Bruegel's painting, *The Tower of Babel,* of the ancient Old Testament myth told in the book of Genesis. The houses depicted in the background of the paintings feature such realistic detail that they bear a remarkable resemblance to those seen in Antwerp today. In the painting they serve to call attention to the secondary building boom, presumably created by the need to house the workers who built the tower. But just as the tower itself is a flawed product, built out of the vain desire of man to reach the heavens so that he can be like God, so is the secondary building boom that flows from it. (More about this painting in Chapter 6)

In the *Two Chained Monkeys*, a small painting, the capitalism of 16th century Antwerp is cast in a most enigmatic light. This work has a haunting sense of mystery about it, especially if we identify with the monkeys, chained and seated on the sill of a window that appears to be in a dungeon. We see through the window a city that is unmistakably Antwerp in the distance, with its picturesque buildings and sailing ships that dot the harbor. While the painting is only 7-7/8 inches by 9 inches, the use of spatial perspective is so effective that it conveys a sense of enormous depth. The straight lines and curves of the manmade window frame the chained monkeys. The city in the distance appears surrealistic in contrast to the monkeys who are apparently dejected at the thought of being held in an unnatural captivity.

Compelling though *Two Chained Monkeys* may be, its meaning has long remained opaque. What were the monkeys doing in Antwerp? Why did Bruegel show them as chained? Interestingly, it is quite possible that there were monkeys in Antwerp in Bruegel's day. After all, the city was a center of world trade that would have included Northern Africa, from where the monkeys could well have come. That said, with Bruegel there is always something more. Perhaps the chains were meant to show how harsh humans had become in subduing the world of

nature. Perhaps Bruegel was using this depiction to suggest that the dynamic, picturesque city in which he lived, one that was so representative of "civilization," had achieved its prosperity at a very definite cost to nature. The question of cost is compounded by the cracked hazelnut on the right side of the windowsill, reflecting an old Netherlandish proverb, "go to court for the sake of a hazelnut." In other words, the monkeys had given away their freedom merely to get the small reward of a hazelnut. Whatever the message, the intrigue of the whole scene is enhanced once we place ourselves as viewers trapped in a dungeon looking at Antwerp from the perspective of two monkeys! Artists had long attempted to portray human suffering, but in *Two Chained Monkeys* we are left with the unnerving question

Plate 21: *Dulle Griet* (*Mad Meg*), Ca. 1562
Oil on panel, 45 1/4 x 63 3/8 in
Museum Mayer van den Bergh
Antwerp

of whether we ought to feel pathos, not just for humans who suffer, but also for animals that have been caged by the very "civilization" whose fruits we so much enjoy.

Bruegel's imagery of the city takes yet another turn in one of his two original paintings that have remained in Antwerp. To see it, one needs to go to the Museum Mayer van den Bergh, a private collection of about 4,000 works put together in the 19th century by the person for whom the museum is named. The highlight of the collection is Bruegel's stunning *Dulle Griet* (also known as *Mad Meg*), a large painting (45-1/4 inches by 63-3/8 inches) so powerful that, upon seeing it, one cannot but gasp at the strange, grotesque figures in the scene, and attempt to figure out what Bruegel was attempting to communicate. (See Plate 21.)

Mad Meg also surprised me because I thought that the collection in Vienna included all of the major styles in which Bruegel painted. Apparently, it did not. The style of *Mad Meg* certainly bears no resemblance to that of his seasonals, nor to the paintings in which abnormal acts are belied by beautiful scenery, nor to his abstracted realism, nor to his genre pieces, and not even to those paintings that portray bits of proverbial moral wisdom. In depicting what is apparently a scene of horror, replete with grotesques, one that has virtually no redemptive images within it, *Mad Meg* reaches into the dark side of our collective life, finding an aesthetic order in the desolation.

Over the years, *Mad Meg* has invited a host of interpretations. Some have seen it as an antiwar statement, especially since it bears something of a resemblance to Picasso's *Guernica*. Others have seen it as an attempt to denounce the Spanish Inquisition of his times, although I think Bruegel does this in a more subtle way in other paintings. More recently, still others have read it as an anti-feminist statement, although one could also see it as a justifiably angry person getting what is rightfully hers (or his). Whatever interpretation one takes, it is hard to miss

the generous use of grotesque figures, such as the man eating fish on the lower right, the crustaceans with human faces on the lower left, the monkey-like figures climbing the slanted wires in the upper right corner, and the Cyclops-like figure on the upper left. With little use of perspective to show depth, the action of the painting is upfront, literally "in our face." In viewing it, we get little relief from the demonic hell of the whole scene. Moreover, all of the colors are dark and somber in tone.

It helps to know that, in portraying the demonic, hellish world of *Mad Meg*, Bruegel was painting in a tradition of medieval art that came to fruition in the work of Hieronymous Bosch (1450-1516). Bosch's painting was unique, certainly for its time, in that it gave expression to otherworldly experiences that are part of what we might consider the inner reality of the human mind. It was widely employed in prints and is reflected in Bruegel's print works. Indeed, it has been said of Bosch that he painted his inner demons and "confront(ed) us with a world of dreams, nightmares in which forms seem to flicker and change before our eyes."

In *Mad Meg* Bruegel depicts a notorious woman of Flemish folklore who reportedly emerged from hell not only victorious but also laden with loot. While the world around her is grotesque, she is portrayed with considerable realism, even if we are left wondering whether the look on her face is one of wretchedness, determination or delight in winning. The townspeople and the soldiers are also depicted with realistic detail, as are the remains of the buildings that frame the action. These odd touches of reality enhance the grotesque feeling we have about the notorious woman. When all is said and done, we are left with a big question. Was Mad Meg the *victim* of a suffocating, hellish world? Or was she the triumphant, defiant *winner* who beat the system, retaliating against it by stealing goods she thought were rightfully hers?

In that Bruegel set the action of this "mad" painting in what appears to be

the ruins of a city, he strongly suggests that we see the city as hell, a cesspool of human distortions, as it were. In this hell chaos reigns. The grotesque takes over. Those who want to preserve their sanity of self simply take whatever they can and flee. This view of the soul of the city contrasts markedly to that of the city as urbanity, the epitome of civilization, or the center of building and progress. It also differs markedly from that of the idealized city that lies in the background of Bruegel's landscape scenes (for example, his seasonal paintings). But it rings true when we think of the underside of urban life so often portrayed in movies and on television. For it is with this underside of city images that forms of human degradation become vivid, even if we prefer not to acknowledge them. Our cities are rife with prostitution, narcotics addition, and criminal violence that ranges from simple assault to murder. If we choose to look, it is in the city that we see populations of those who are homeless, the poor, the wretched and the despairing. In capturing this sordid "under-life" of the city, Bruegel has once again enabled us to see a side of our collective selves both as it was 450 years ago and as it is today. While we may generally want to emphasize the positive side of city life, we also need to bear in mind that there is a grotesqueness that lies beneath the surface of the "normality" we treasure.

Bruegel's other work at the Museum Mayer van den Bergh, *Twelve Proverbs*, is of such a different character, style and tone from *Mad Meg* that one wonders whether it was painted by the same person. (See Plate 22.) *Twelve Proverbs* neither shows us another side of ourselves nor makes a biting social judgment. Instead, it advances simple, straightforward, descriptive depictions of proverbial folk wisdom. They are what they are. Nevertheless, they do show Bruegel's great fascination with capturing on canvas the wisdom and life of the Flemish people of his time. This fascination comes to fruition in an entirely different way in Bruegel's *The Netherlandish Proverbs*, a magnificent depiction of the essence of

Plate 22: *Twelve Proverbs* , Ca. 1558-60
Oil on panel, 29 1/3 x 38 3/4 in
Museum Mayer van den Berg
Antwerp

Flemish culture that hangs in Berlin. (See Chapter 5.)

Leaving the Museum Mayer van den Bergh with its graphic, demonic portrayal of urbanity, you are brought back to the reality of present day Antwerp. On the surface Antwerp is similar to many other cities around the world, although its function as a world center for the diamond and jewelry trades makes it unique. During the twenty-minute walk from the Museum Mayer van den Bergh to the railroad station, one passes dozens of jewelry shops where one can purchase virtually any size, shape or type of diamond. A sight along the way is Diamondland, a museum of diamonds with exhibitions showing how the stones are mined, cut,

sometime between 977 and 979 A.D., when it was given to a duke, Charles of France, by Otto II, ruler of the Holy Roman Empire. It subsequently became a trading center because its location made possible the control of trade routes that linked Bruges, then the largest port on the coast of the North Sea, to Cologne, the most powerful trading center of Germany. The 14th century saw the rise and fall of the cloth industry, accompanied both by population expansion and periods of public disorder. Nevertheless, by 1430, under Phillip the Good, the town became a major administrative center, part of the Burgundian duke's complex of territories.

The city of Brussels would undergo tremendous changes during the following centuries. By the turn of the twentieth century it had emerged as a dynamic center of European art and society. The dynamism was dampened with two periods of German occupation, one from 1914 to 1918 and the second from 1940 to 1942. Nevertheless, in the post World War II era it regained its character as a capitol city, and today it stands both as a national and as a European center of governance. Concerning the latter, it houses three of the five institutions that form the core of the European Union, namely, the European Parliament (headquartered in Strasbourg but holding many committee and political group meetings in Brussels), the Council of Ministers and, most important, the European Commission (where 10,000 of its 13,200 civil servants work). Although it has a considerable amount of industry and trade, its functioning as a center of national and European governance gives it a very different "pulse" from Antwerp, where international trade clearly dominates. From an American perspective, the difference between the two cities is analogous to that between Washington, D.C., the political capital, and New York City, the financial capital.

The Brussels of Bruegel's day (1563-69) was much influenced, indeed dominated, by the presence of Charles V. He was Charles of Habsburg, a Burgundian Prince born in 1504. In 1519, at the age of 15, he made his unofficial

entry into Brussels. In the following years he would ascend to the throne of Spain with its territories in the Americas, and be elected Emperor of Germany, thereby ruling (from Brussels) an empire "on whose states the sun never set." Calling himself Charles the Majestic, Universal Emperor, Prince of Peace, he adopted the Golden Fleece as the emblem of the Habsburgs, under which he ruled until his abdication in 1555. During this time Brussels, literally his own capital city, thrived as a beautiful and great city to which people flocked.

Charles V's abdication in 1555 was an event (actually a series of events) that shocked Brussels in the latter years of Bruegel's life. Although the precise reasons were never made known, there was reportedly much weeping during the event, and the abdication was completed with Charles signing himself into a monastery. At the same time, he granted his Spanish possessions to his son, Philip II. The times were full of great social unrest and an outright rebellion in 1566 fueled by the misery and abject poverty of the workers, as well as by the spread of the Reformation, especially Calvinism. The austere Philip II responded to the unrest by sending the Duke of Alba, who initiated a vicious inquisition aimed at maintaining the strict orthodoxy of the Roman Catholic Church.

By any standard, the reign of the Duke of Alba was horrific. Its aim was nothing less than to reestablish the orthodoxy of the Roman Catholic Church both by "extirpating the Protestant contagion in the north…(and)…removing the taint of Islam and Judaism from the land of Spain." In the area of Brussels, thousands of "heretic" Protestants—or even people suspected of thinking like Protestants—were tortured and put to death. So brutal and arbitrary was the repression that it set off an "eighty year war" (1566-1648), in which the people of the area of the Low Countries (modern day Belgium and Holland) fought to free themselves from political and religious suppression and domination.

While many of Bruegel's paintings give profound expression to the violence,

repression, and social turmoil of the times in which he lived, his personal life appears to have been reasonably stable. During the first years of his adult life he lived in Antwerp where, as we noted earlier, he was registered as a painter in 1551. The years in Antwerp (interrupted by a trip to France and Italy between 1552 and 1554—see following chapter) were ones in which he presumably became established as an artist, mostly through his work as designer of prints. There were a few paintings dated during his Antwerp years, the earliest of which is *Landscape with Christ Appearing to the Apostles at the Sea of Tiberius,* which he completed in 1553. The next is dated four years later in 1557, his *Parable of the Sower*. (See Chapter 5) Although he then proceeded to paint his three great comprehensive-abstract works and four others in 1562, the bulk of his paintings, including the five seasonals, the three genre pieces, and many of his works that gave expression to myths and morals, were completed in the brief span of the six years he lived in Brussels (1563-1569).

At first sight Bruegel's move from Antwerp to Brussels appears to have been motivated by professional concerns. After all, Brussels was at the time the capital city of the Habsburg Empire, and it may well have been that the number of patrons and demands for his art were greater there than in Antwerp. The move did coincide with a change in his style of work. He appears to have stopped work in print design in 1561 and thereafter devoted himself completely to painting.

However, the move may also have had a personal side, a "spicy" one at that. As told by Carl van Mander, the "unauthorized biographer" mentioned above, Bruegel's move to Brussels had a very personal motivation,

As long as he remained in Antwerp, he lived with a servant girl whom indeed he would have married, had it not been for the unfortunate fact that she used to lie all of the time, which was repugnant to his love of truth. He made a contract

or agreement with her that he would check off all her lies upon a stick. For this purpose he took a fairly long one, and he said that if the stick became full of notches in the course of time it would prevent the wedding. This happened before much time had elapsed.

Whether it was Bruegel's "love of truth" or his desire to move ahead in his life of painting, he left his lover in the lurch at the request of his mother-in-law to be when he married Marianna Coeck. Reportedly it was his mother-in-law who demanded that he move to Brussels "…in order to get his former girl out of sight and out of mind."

Whatever Bruegel's personal motivations, the professional implications of his marriage to Marianna Coeck and move to Brussels were enormous. As the court painter to Charles V, Pieter Coeck, Marianna's father, must have had "connections" that would have been of use to Bruegel. The marriage also led to an intermingling of Bruegel's personal and professional life, because it was through the marriage to Marianna that Bruegel would found a family dynasty of painters, which would last for several generations. Moreover, perhaps with the intention of solidifying these changes in his personal life, Bruegel altered the spelling of his last name. Whereas it had been Brueghel, he dropped the "h" to make it Bruegel. (Today, some references continue to use the former spelling.)

So far as we can tell, Bruegel did not capture the aesthetics of Brussels the way he did of Antwerp. There are no identifiable city skylines and no specific city scenes. Rather, the many works he painted, or dated, during the years he lived there, give generalized expressions to social concepts that range from the conflict and violence that were such a part of the social reality of his times, to the balance between man and nature implicit in agrarian society. It was in Brussels that Bruegel emerged as a painter of the Renaissance who combined the big picture

perspective of the landscape painter with meticulous attention to detail, in order to bring to life the inner meaning of social myths, proverbs and folk wisdom. At the same time, he was also the painter of the Reformation who could paint both works that embodied traditional religious scenes, which would have appealed to Roman Catholics, and works that were extremely critical of the universal church, which could well have appealed to Protestants. When his work is seen in its entirety, one can only marvel at how many aspects of his times and culture Bruegel was able to conceptualize put on canvas in the short period of the six years he lived in Brussels.

Demonstrating the universality and cross-cultural appeal of Bruegel's art, few of his original paintings remain in Brussels. Nevertheless, of the paintings dated between 1563 and 1569, two are there, namely, *The Census at Bethlehem* and *Winter Landscape with Skaters and a Bird Trap*. Both are on view at the Museum Royaux des Beaux-Arts. The museum also houses two paintings that were completed during Bruegel's Antwerp years: *Landscape with the Fall of Icarus* and *Fall of the Rebel Angels*.

Like the Kunsthistorisches Museum in Vienna, the Museum Royaux des Beaux-Arts has a Bruegel room. Set up in the early 20th century, it contains three Bruegel originals in addition to copies of his works by his son, Pieter The Younger, and a number of original works by his other son, Jan. Each of the three originals is unique and, it turns out, quite different from the paintings in Vienna.

Look first at *Landscape with the Fall of Icarus*, one of Bruegel's earliest paintings, completed while he was still living in Antwerp. (See Plate 23.) His only painting of an ancient myth that is secular rather than Biblical, it depicts the ancient belief that only the gods could fly through the air. While we moderns may think of flying as a "technical" problem that has been overcome, the myth also has a social spin, in that it can be taken as a parable of what will happen to all those

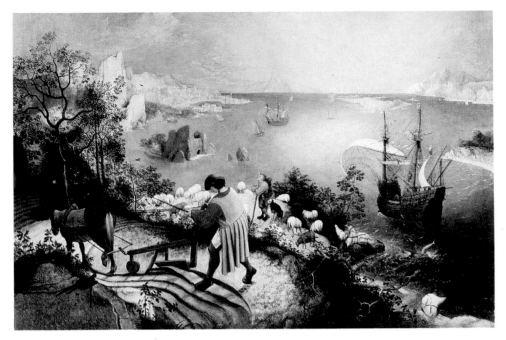

Plate 23: *Landscape with the Fall of Icarus*, Ca.1558
Oil on canvas, 29 x 44 1/8 in
Musee d'Art Ancien, Royaux des Beaux-Arts
Brussels

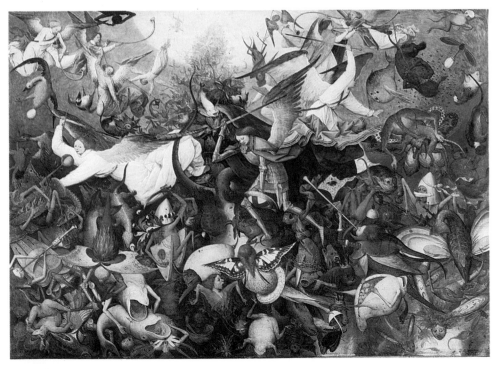

Plate 24: *Fall of the Rebel Angels*, 1562
Oil on panel, 46 x 63 3/4 in
Musee d'Art Ancien, Musees Royaux des Beaux-Arts
Brussels

who seek to rise above their station in life. In portraying the myth on canvas, Bruegel captured its essence expressed centuries earlier by the Latin poet Ovid in his *Metamorphosis*:

> …some fisher, perhaps, plying his quivering rod, some shepherd leaning on his staff, or a peasant bent over his plough handle caught sight of them as they flew past and stood stock still in astonishment, believing that these creatures who could fly through the air must be gods.

Actually, Bruegel took Ovid's meaning one step further, by showing the ploughman as apparently oblivious to the fate of Icarus.

There is much meaning in this painting that is "up front." But when studied further, especially upon seeing it in the original, one realizes that Bruegel's use of artistic techniques to depict moral truth is little short of astounding. Sharp color contrasts are used to create the perspective of depth. The colors vary from the bright red tunic of the man guiding the plow in the foreground of the painting to the pale white mountains and striking whites used for depicting the mountains, buildings and skies on the horizon line. There is another contrast, between the incredibly beautiful landscape, which one simply cannot miss, and the central character depicting the theme of the painting, which is so obscure that he is literally lost. One strains to find Icarus, realizing only gradually that the two bare legs in the lower right corner, one protruding from the water and the other still submerged, are all that remain of Icarus after his foible. Finally, in depicting the ploughman as oblivious to the fate of Icarus, Bruegel has subtly brought in still another moral truth, embodied in a German proverb, well known in Bruegel's day yet still understandable to us, "no plough is stopped for the sake of a dying man."

Both the complexity of the myth and the moral truths are gracefully retold

by W.H. Auden, who was so inspired by the painting that he wrote the following poem, and thereby "translated" Bruegel's pictorial representation of Ovid back into words!

In Brueghel's *Icarus* for instance: how everything turns away

Quite leisurely from the disaster; the ploughman may

Have heard the splash, the forsaken cry,

But for him it was not an important failure; the sun shone

As it had to on the white legs disappearing into the green water:

And the expensive delicate ship that must have seen

Something amazing, a boy falling out of the sky,

Had somewhere to get to and sailed calmly on.

Although it, too, incorporates the theme of "falling," *Fall of the Rebel Angels* is a very different type of painting. (See Plate 24.) Its theme is religious and drawn directly from the theology of the Middle Ages. It tells the story of Lucifer and his angels, a story that originated as a Jewish legend and later passed into Christian theology. It depicts how fallen angels become transformed into monsters as they tumble from the beauty of heaven into the mire of hell. Bruegel depicted the notion of moral fall through a generous use of grotesque figures, such as fishes with open mouths ready to devour anything that comes their way. Reptiles and human skeletons fill out the picture of what can only be described as an anarchic, agonizing, hellish, demoralized world. Containing relatively little depth perspective, the action of this painting is upfront, "in our faces." The canvas is so packed with actions and figures that we get little relief from the scene. Rather than conveying depth, the sharp color contrasts serve to emphasize the enormous difference between heaven and hell.

Fall of the Rebel Angels is one of three paintings in which Bruegel employs a generous use of grotesques, pioneered by his predecessor, Hieronymous Bosch. Seen alongside of *Triumph of Death* (Plate 2) and *Mad Meg* (see Plate 21), *Fall of the Rebel Angels* may well have led Carl van Mander to write that Bruegel

> …practiced a good deal in the manner of Jeroon (Hieronymous) van den Bosch and made many similar, weird scenes and drolleries. For this reason, he was often called Pieter den Droll. (Peter the Droll)

Van Mander's somewhat patronizing view of Bruegel, as simply a follower of Bosch, would cast a negative influence on Bruegel's reputation in art circles that would persist for centuries. The irony is that van Mander's view is, simply put, incorrect. Bruegel painted only three of his major works in the style of Bosch. Moreover, in *Fall of the Rebel Angels* there is a fascinating "redeeming feature," painted in realistic style, that contrasts sharply with the demonic/fantastic style of the remaining figures. As the viewer looks closely, s/he cannot fail to see the beautiful butterfly wings painted in sharply realistic detail on the creature below Saint Michael (in the dead center), suggesting in the words of one recent commentator "…sin *can* be attractive in its own way."

In short, just as he had in *Triumph of Death* and *Mad Meg*, Bruegel inserted into *Fall of the Rebel Angels* realistic details that contrasted sharply to the otherwise demonic/fantastic reality depicted in the painting. This technique demonstrates a way of thinking about the complexity of social reality. We all know that our social world can be described by using polarized opposites, and that there are two sides to every question. In Bruegel's world, as painted in these scenes, however, it is the realistic details that contrast to the demonic/fantastic realities, and thereby demonstrate that polar opposites can exist alongside each other. One might say

that the touches of realism serve as redemption from the horrors of chaos and hell. The more we examine the paintings, the more we become fascinated by these touches of this-world reality. They convey a certain beauty and order that contrast dramatically to the larger world of horror, chaos, and hell that is portrayed.

The third original Bruegel at the Musee des Beaux Arts is *The Census at Bethlehem*. (See Plate 8.) More serene than the two paintings about "falling," it is very much in the style of the seasonals that are in Vienna. The colors are robust. The scene could be one of village life. People are involved in their everyday work and leisure. The focus of the action is the figures in the foreground moving toward the inn, so that they can be counted. Joseph and Mary, the real subjects of the painting, are but two of many; their identity is revealed only by the ox, the ass, and the blue mantle worn by Mary. The whole scene is painted with such realism that one must think twice to realize it is displaced and created. The actual census described in Luke 2, verses 1 to 5, took place nearly 1,600 years earlier, in the place that knew neither snow nor small villages with neatly roofed houses and inns. Moreover, although of Roman origin, census taking did not begin in Europe until the 1700's, long after Bruegel painted. This painting is a superb example of how Bruegel used the techniques of realism employed by painters of the Renaissance to bring ancient Biblical stories into the Flemish life of his times.

Even though Bruegel painted no scenes that typify the city of Brussels, there are, in addition to his room at the Musees de Beaux Arts places in Brussels where his presence is very much celebrated. There is 132 Rue Haute, a quaint red brick house, now open to the public, that was reportedly his residence. He is buried in Notre Dame de la Chapelle. While there is only the grave stone, seeing it made me think of the glowing eulogy offered to him about five years after his death by his friend Abraham Ortels (1527-98).

That Pieter Bruegel was the most perfect painter of his century no one, except a man who is envious, jealous or ignorant of that art, will ever deny. He was snatched away from us in the flower of his age. Whether I should attribute this to Death who may have thought him older than he was on account of his supreme skill in art, or rather to nature who feared that his genius for dexterous imitation would bring her into contempt, I cannot say.

On the last day of the trip to Brussels, the search for "things Bruegel" led my wife and me to a marvelous restaurant, La Maison du Cygne (House of the Swan), located on the corner of the Grand Place town square. According to our guidebook, there were two "priceless Bruegels" in the restaurant. Having seen a fair number of magnificent Bruegels, I wondered how two could have escaped my attention. My curiosity was piqued further when I learned that Karl Marx used to frequent the establishment.

So it was with some anticipation that we went to La Maison du Cygne with the idea of dining, in order to see more Bruegel paintings. Upon entering the restaurant, I was captivated by its elegant décor, leading me to wonder how it was that Karl Marx could have eaten so lavishly while writing books dealing with capitalistic exploitation of workers. This paradox was clarified when I learned that La Maison du Cygne was but a tavern when Marx ate there. My other reaction was that, in looking around the restaurant, I found no Bruegel paintings; to be sure, there were several other Old Masters, but no Bruegels. Even a trip to the rest rooms on the other side of the dining room proved of no avail. We decided to be patient and enjoyed a marvelous dish of lamb, "agneau pavillac a Cygne," and then relaxed with coffee and dessert until well after 2:00 p.m.

Our patience was rewarded when, on the way out of the restaurant, we asked the headwaiter where the Bruegel paintings were located. He very politely

directed us upstairs by way of a circular staircase. Ascending to an upper floor banquet hall, we suddenly feasted our eyes on two great Bruegel paintings, *The Massacre of the Innocents* and *The Netherlandish Proverbs*. To be sure, these were copies, possibly by Pieter, The Younger, because the location of the original of the former is not known (the one in Vienna is considered to be "after Bruegel") while the location of the original of the latter is in Berlin. However, it was marvelous to see these two major Bruegel paintings hanging in a "real world" public space outside of a museum, available to be appreciated and enjoyed by people attending a banquet.

Moreover, by associating the paintings with Karl Marx, we can see deeper into Ortels' observation that Bruegel "painted things that cannot be depicted." In

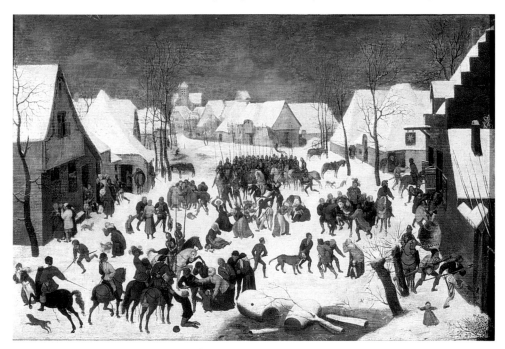

Plate 25: *The Massacre of the Innocents*, 1564
Oil on panel, 17 1/4 x 25 1/2 in
Upton House, Bearsted Collection
Banbury, Oxfordshire

The Massacre of the Innocents Bruegel had portrayed a horrific abuse of power (see Plate 25); in *The Netherlandish Proverbs* he had abstracted no fewer than 119 pieces of proverbial Flemish culture, and recombined them into an integrated whole. (See Chapter 5.) In *Das Capital* Marx demonstrated at length the social injustices committed by the upper classes, as they forced peasants off their land, thereby pushing them into the status of lower-class, landless laborers with only their "labor power" to sell to capitalists, who would exploit them in every way possible. In his other writings, Marx also showed how capitalists abstracted and then subverted cultural values, in order to use them for their own ends. There are, of course, many points on which Bruegel and Marx could well disagree, but both depicted social reality in new ways that others of their time either hardly glimpsed or saw only in a conventional manner.

The Antwerp/Brussels trip allowed me to see more deeply into Bruegel's art. While Vienna enjoys something of a monopoly on Bruegel paintings, especially those featuring his realistic style, Antwerp has the hellish, ghoulish world of *Mad Meg* and Brussels has the wonderful portrayal of the ancient myth, *Landscape with the Fall of Icarus*. If the world depicted by Bruegel appeared orderly and peaceful in paintings such as *The Census at Bethlehem*, it bordered on chaos in *Mad Meg*. *Two Chained Monkeys* displayed the ongoing conflict between humans and their natural environment. The realistic detail of the beautiful butterfly wings in *Fall of the Rebel Angels* contrasts to the demonic of the creatures that fall into sin. So much is embedded in Bruegel paintings that one can hardly disagree with Ortels, that Bruegel painted that which cannot be painted. On the surface, Bruegel paintings may be exquisite landscapes, but they also have deeper meanings in them. To see the deeper meanings is to realize that Bruegel painted a certain something more; indeed, much, much more.

After the Antwerp/Brussels experience, I resolved to travel wherever necessary

to see the originals of each Pieter Bruegel painting. This quest would take me first to Rome and Naples to visit cities to which Bruegel himself had traveled between 1552 and 1554, and then to a number of cities in western and eastern Europe, as well as to several in the United States. While traveling these considerable distances, I could not help but think how remarkable it was that Bruegel's work seemed to transcend both time and place. Why is it, I asked myself, that his depictions of life and the almost mysterious "something more" in his art continues to charm us and hold our interest, even though we live more than four centuries later and in places rather far removed?

Chapter 4
Rome and Naples, 2001

It was the French philosopher/essayist Montaigne (1533-92), a contemporary of Bruegel whom he probably never met, who noted that travel is a "profitable exercise" in which the mind is constantly stimulated by observing new and unknown things. He compared travel to stay-at-home life, in which customs and set attitudes dull the senses. A true sophisticate, Montaigne saw the traveler as one who would not be offended if she or he were to encounter the outrageous or the bizarre. His belief was that the traveler should be one who journeys with "cosmopolitan skepticism" in order to enjoy not simply seeing scenes but, rather, experiencing them as they embody culture. The end result is that Montaigne's traveler would better understand and appreciate his or her own world.

Montaigne's approach to travel is, to say the least, challenging. People have always traveled for reasons that are many and varied. In Montaigne's day, as in ours, much travel was for business and trade. "International" businesses that were run from cities such as Venice, Genoa and Lisbon regularly sent representatives to the cities of northern Europe, some of who would live there for months or years

at a time. Other businessmen were constantly "on the road" as they accompanied trade fairs that moved from city to city. Some travel was religious with believers making various kinds of pilgrimages to Rome and other "holy" cities. Wars, in their own way, involved travel (and, for many, adventure) to places far away from home. Finally, there was the travel involved in exploring the "new world." In 1492 the very courageous Christopher Columbus changed the course of history when he traveled "off the map," in his attempt to realize the long held dream of finding a way to the East Indies. Driving home the importance of travel in Montaigne's times was the prosperity that ensued from exploiting the mineral wealth that had been unearthed in the new world.

Very much in the spirit of Montaigne's "cosmopolitan skepticism," Pieter Bruegel traveled in order to enhance his art. Although the details of Bruegel's travels are sketchy, there is documentation strongly suggesting that he spent roughly two years, between 1552 and 1554, journeying to Southern Italy and Rome, going south and east from Antwerp through France, and returning north and west through the Alps. The trip came at a significant time for him, since in 1552, he would have been in his mid-twenties, living in Antwerp and working chiefly as a designer of prints. His print work and his painting were much enhanced by what he saw. Of more importance, the experience may well have served as the impetus for his change in artistic focus, from designer of prints to full-time painter. Only one of his major landscape paintings is dated during the time in which he would have been traveling. Judging by the dates, his major paintings were produced long after his return to Antwerp.

For a young Flemish painter from Northern Europe in the mid 16th century, Italy was the place to go. There was some irony in this because oil painting had been developed by the artists of Northern Europe, in particular Robert Campin (active as a painter, 1406-44) and Jan van Eyck (1390-1441). Northern Europe

could also claim the strikingly fine line work that defined the art of Albrecht Durer (1471-1528). However, the Italian painters, of whom there were many in the emerging Renaissance cities, had readily absorbed the techniques of oil painting, so that they were masters not only of the egg tempura based wall fresco painting but also of the oil based easel painting. More than technique, they had created a High Renaissance style of art that dated from the period 1485-1519, when the production of art was dominated by the three great Italians, namely, Leonardo DaVinci (1452-1519), Michelangelo (1475-1564) and Raphael (1483-1520). Although based in Florence, these three masters also worked and left their influence in Rome, Venice and other Italian cities.

The importance of artists actually living in the places where "cutting edge" art was produced was later documented by Eugene Fromentin, the 19th century French landscape painter, as well as writer and traveler, who embarked on his own journey to the lowlands of Europe, with the intention of learning the secrets of the genius and talents of the Old Masters of Belgium and Holland. As he shrewdly noted,

>Flanders did to Italy what Italy had been doing to antiquity; she turned to Rome, Florence, Milan, Parma and Venice, even as Rome and Milan, Florence and Parma had turned towards Latin Rome and Greece.

Although Fromentin omits mention of Bruegel at this point in his commentary, he notes that a number of Flemish artists went to Italy beginning with Mabuse in 1508, who was followed by Van Orly in 1527, and then Floris and others. Fromentin goes on to say that the experience of traveling to Italy affected each of the artists in a different way. Mabuse remained "Gothic in mind and execution," and Van Orly "freer, more supple, more nervous." Floris returned "unrecognizable...with a turbulent and cold manner...irregular style and thin execution."

Fromentin's observation of the change in Floris' painting unwittingly provides a wonderful demonstration of Bruegel's genius. With the changes in his artistic techniques, Floris returned from his Italian years to enjoy what was, for the times, a very successful professional career, in which he produced works for his patrons that were of Italian style and quality, but lacking in imagination. In contrast to Floris (and the many other painters who had traveled to Italy), Bruegel absorbed, imbibed, and digested the aesthetics of Italian art, without succumbing to its more lyrical expressive style. His learning must have been distinctly visceral or kinesthetic, because upon his return home, as his early biographer put it,

> Pieter painted many pictures from life on his (Italian) journey, so that it was said of him, that while he visited the Alps, he had swallowed all the mountains and cliffs, and, upon coming home, he had spat them forth upon his canvas and panels; so remarkably was he able to follow these and other works of nature.

As always with Bruegel, the proof is in the pictures. Bear in mind that there are no sharp, jagged Alpine mountain peaks in the lowlands of the Flemish countryside, as you look at an example of his landscape print in Plate 26. Think back to the backgrounds in *The Suicide of Saul* and the *Conversion of Saint Paul*, in which the Alpine-like surroundings enhance the stark spiritual nature of the personal experiences portrayed. (See Plates 11 and 10.)

Bruegel's ability to travel with the "cosmopolitan skepticism" of Montaigne allowed him to enrich the techniques of Renaissance realism, rather than simply imitate the expressive style of the Italian masters. The full expression of Bruegel's genius would become visible years later, when he painted the lives of real people who were not posed, and who interacted with one another in ways that ranged from the joys of play and dance to the tragedies of entrapments, in all kinds of

Plate 26: *Alpine Landscape with a River descending from the Mountains into A Valley,* Ca. 1553
Pen and brown ink, 9 1/4 x 13 1/2 in
Louvre
Paris

moral dilemmas. In contrast to Floris and other Flemish painters of the day, Bruegel's work subsequent to his journey to Italy featured a focused realism, one that embraced the details of reality and, at the same time, contained an inner meaning that incorporated the folkways, mores, and even the social critiques of the society of his day. He would go beyond the Italian masters to found two new major branches of painting, namely, abstracted empiricism and genre art. (See chapter 2) In so doing, he would contribute greatly to the realistic-moral style of art that pervades Flemish and later Dutch painting. He would also earn himself a key place in the Northern Renaissance, which enabled art to continue to develop beyond the work of the great Italian masters.

It was with a "cosmopolitan skepticism" that I traveled to Rome and Naples in 2001, both to see these great cities and also to understand how they might have been seen by Bruegel and influenced his art. Also, they had museums that housed three of his paintings other than those we have already seen, one in Rome and two in Naples.

Rome calls itself the eternal city. Though not really "eternal," it is at least 2,700 years old and has long been a world center. If not quite all roads lead there, most do. From its temples of the ancient world to its museums of modern art, the almost endless sights provide a visual display of both its history and role in world events. Its Foro Romano (Roman Forum) and Ostia Antica, the main port of an ancient city, provide dramatic proof that Rome was the seat of secular power in the ancient world—a power based on a culture that may have been, in large part, Greek, but one which came to define "civilization" in its day. At the same time, its Vatican Palace, where Popes have been in continuous residence since 1377, symbolizes its center of sacred power that dates back to 68 A.D., when St. Peter was martyred there. Paralleling the ups and downs of the western world, Rome has seen extensive destruction, as it was sacked and pillaged at the time of its "fall" in 476 A.D., and great rebirth as a Renaissance city, beginning in the 15th century A.D.

With a visit to the Coliseum, you can see how Bruegel caught the aesthetic essence of Rome so dramatically in his painting *The Tower of Babel*. (See Plate 13.) Once one ignores (or attempts to ignore) the large numbers of tourists at the Coliseum, one simply cannot miss its striking resemblance to the tower as depicted by Bruegel. At the same time, it was also clear that Bruegel had employed artistic license in depicting the tower somewhat atilt, in order to suggest that the structures built by humans are inherently imperfect. To be sure, the Coliseum is a ruin and the structure is only a portion of what it once was. Nevertheless, looking at it through the lens of Bruegel's painting, you can readily see the Coliseum as a

powerful, commanding visual metaphor of Western civilization.

Looking at the Coliseum and imagining your fellow tourists as spectators, it is easy to feel you are present at the games. While the games represented the glory of ancient Rome, they also gave expression to a power that was so corrupt, it could sponsor spectacles that toyed with the lives of gladiator-slaves, who were thrown to the lions or made to battle to the death, simply so that spectators could feel the thrill. Yet, by the same token, in the same Coliseum these gladiator-slaves would become martyrs upon whose faith a new Rome would emerge. But sacred authority would also come to be compromised by corruption. To viewers of Bruegel's day, among whom were included Protestants and "free thinkers" of varying religious persuasions, there was little doubt that Bruegel's depiction of the

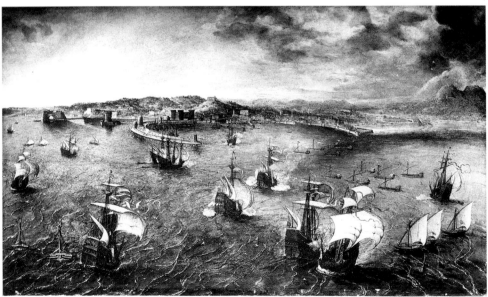

5379 - ROMA - Veduta del Porto di Napoli - Breughel - Gall. Doria - Anderson

Plate 27: *A View of Naples*, 1560-62
Oil on panel, 15 3/4 x 27 3/8 in
The Italian caption within the painting reads: Verduta del Porto diNapoli (The Old Port of Naples) but the painting is generally known in English as "A View of Naples"
Galleria Doria Pamphili
Rome

Coliseum as the Tower of Babel rang true, because it was the quintessential symbol of the corruption into which the Roman Catholic Church had degenerated. (More on this powerful painting in Chapter 6.)

Rome held something of a surprise, in that it is home to Bruegel's *A View of Naples*, one of his few paintings that does not seem aesthetically right to me. (See Plate 27.) To begin with, one could argue in light of its subject matter, that the painting should hang in Naples rather than Rome, especially since many scholars interpret the painting as "proof" of Bruegel's stay in Southern Italy. Second, unlike the many Bruegel paintings that typify Renaissance realism, the action of this painting is difficult to define. Because it is based on an earlier drawing of Bruegel's that depicted a battle in the Straits of Messina, most scholars have regarded the scene as a naval skirmish. But, the problem is that, when you look at it more closely, the ships are not aligned for waging war. Third, as I would see later when I visited Naples, the apparent realism of the painting is misleading. If you draw a diagonal line from the top left to the bottom right of the painting, the part of the painting above the line blurs into allegory. Indeed, the circular shape of the jetty is Bruegel's reinterpretation of a much less attractive rectangular one that existed in his day, and still exists in ours.

Finally, *A View of Naples* is one of the few Bruegel paintings that does not challenge the viewer by raising significant philosophical or moral questions. Neither signed nor dated by Bruegel, it is totally different in character from *Children's Games*, although both are thought to have been painted in the same year. I would question whether it is really a Bruegel painting. Yet, professional opinion argues that it is, even though the same professionals have had difficulty placing the painting within the larger body of his work. Nevertheless, I cannot find any other painting in which Bruegel both blurs realism and allegory, without any discernible aesthetic gain, and omits any hint of either moral ambiguity or social

statement.

My disappointment with *A View of Naples* was short lived. The painting hangs in the Galleria Doria Pamphili, the sumptuous palazzo of a Roman noble family who, in earlier times, served as bankers to the Pope, and was deeply involved in the politics of papal power. The family had superb taste for art and the means to indulge it. Room after room contains paintings displayed in 17th century style, from floor to ceiling. There are many well-known ones, including Caravaggio's *Rest on the Flight to Egypt*. But the real surprise of the visit came when I unexpectedly found a set of five paintings by Pieter's son, Jan, known as the "Velvet Bruegel." These were complete allegorical paintings in their own right, full of detailed colorful depictions. There was one for each of the four elements known to the ancient world: fire, air, earth, and water, plus a fifth that was a conception of the Garden of Eden. Although I still preferred the Renaissance realistic style of Pieter Bruegel, The Elder, this was one place in my travels where I felt that Pieter's painting was trumped by his very gifted, if not quite so well known son, Jan.

The other city in Italy in which to see Bruegel paintings is Naples. It is a very different kind of city than Rome. Reading the travel guides gives an initial feeling about Naples that is not very encouraging. *Fodor's* opens its remarks on Naples by quoting Herbert Kulby, an early visitor, who observed in his *American in Italy*, "The comedy is broad, the tragedy violent. The curtain never rings down." The travel guide goes on to assert that whether it is the sense of doom that results from living in the shadow of Vesuvius or the poverty and overcrowding, "Naples is a difficult place for the casual tourist to quickly like." As if to add to the anxiety, it goes on to offer the unnerving advice that, while in Naples, one should keep a firm grip on the pocketbook and camera or, better yet, leave valuables in the hotel safe.

Fodor's hesitancy about Naples is duly confirmed when one enters the city

from its land-based side, traveling by train from Rome. The high-speed train ride of several hours takes you through a beautiful, verdant countryside dotted by farms. Literally out of the blue, you encounter Naples as a seemingly endless number of nondescript apartment and office buildings. One looks in vain for a skyline or part of a skyline that is picturesque. The present-day view of Naples is a far cry from the one painted in *A View of Naples*, whether one looks at it realistically or allegorically. Approaching the city, I wondered, had Naples changed so much since Bruegel's day that it was now an unrecognizable hodge-podge of modern urbanity? Or, had Bruegel already recognized the "difficult" nature of Naples and chosen to drift into allegory, because he did not want to depict the reality of the place?

Travel was also problematic once my wife and I arrived in Naples. Hailing a taxi was fairly easy, but I have never seen such gridlock as there was that day on the streets around the main railroad terminal. Getting through the maze of cars, trucks, and taxis that were nearly perpendicular to each other reminded me of trying to move the interlocked pieces of a child's puzzle, in which there is only one open space. Finally free from this maze, it was but a short drive to the bed and breakfast in which we had made a reservation. But another surprise lurked there, in that the taxi driver wanted 15 euros, even though our host had assured us that the fare should be no more than seven. Feeling somewhat cheated, I nevertheless decided to pay and turned my sights toward finding a way of appreciating this problematic city.

The first thing I began to realize about Naples is that it is not simply another Italian city. Long a trading center because of its location on the Tyrrhenian Sea, by the early 1500's, during Bruegel's lifetime, it had emerged as one of the key cities of the Levant trade that interlinked eastern and western merchants. Later, during 1797-1799, it became a republic under Napoleonic rule, with its own monarch

who had ties to Napoleon, a model constitution, and French-style administration. Moreover, it remained a republic until it was merged into modern Italy in 1860. Although the extent of its trade in no way rivaled that of Venice, Naples was a distinct power in its own right.

The "soul" of Naples begins to make more sense when one realizes its proximity to Mt. Vesuvius. Naples is but six miles north of Ercolano (Herculaneum) and 15 miles northwest of Pompeii, the two cities destroyed by the eruption of Mt. Vesuvius in 79 A.D. The surprises of the eruption and the subsequent covering of ashes and cinders must have been astounding as they overcame people simply going about their everyday lives. You cannot but reflect upon the inherent precariousness of life as you see Mt. Vesusius continuously, while riding on the metro from Naples on the way to view the excavated ruins at Ercolano and Pompeii. No wonder people in Naples, only a few miles away, live for today rather than tomorrow. The full significance of the precariousness of life would later confront me personally, with the catastrophic events of 9/11/01, in my hometown of New York. While the death and destruction attached to the eruption of Mt. Vesusius were of a different order, the devastation of both events was horrendous and the surprise equally great.

Concerning Bruegel, the unexpected "find" in Naples was two of his magnificent paintings, *The Blind Leading the Blind* and *The Misanthrope* (also known as *The Faithlessness of the World*), both of which hang at the Museo Capodimonte. (See Plates 28 and 29.) Naples is unique in having two Bruegel paintings. Aside from Vienna, Brussels, and Antwerp, only Berlin and Naples have more than one. Moreover, the two Bruegel paintings hanging in Naples, while reproduced in various books of art, have not been so extensively copied as have so many other Bruegel works. In the Capodimonte they are considered the "cornerstone" of the Farnese Collection, one of the most extensive of European

Plate 28: *The Blind Leading the Blind*, 1568
Oil on canvas, 37 7/8 x 60 5/8 in
Museo Nazionale di Capodimonte
Naples

Plate 29: *The Misanthrope* (The Faithlessness of the World), 1568
Oil on canvas, 33 7/8 x 33 1/2 in
Museo Nazionale di Capodimonte
Naples

16th-18th century art, and probably the most extensive collection of non-Italian old masters in Italy. The origin of the collection dates back to Bruegel's times, when it was begun by Margaret of Austria, the natural-born daughter of Charles V, who married the Duke Ottavio Farnese in 1538 and became Regent of the Low Countries from 1559 to 1567. It was some years later when Giovani Battista Masi put the collection together, during his stay in Flanders between 1571 and 1594, while working as secretary to Prince Allesandro, the son of Duke Ottavio Farnese.

In *The Blind Leading the Blind* Bruegel painted the ultimate paradox. How can we see the blind? How can we see blindness? We know that we can see "them," but the look of the faces of the figures in the painting demonstrates clearly that they cannot see us. Nor can they see the tranquil beauty of their surroundings. They do not know of the field, across from which there is a church and two houses (the top visible on only one). Nor can they see that the colors of the painting are dominated by gray (and to a lesser extent blue) hues, as the scene would appear to those who are color-blind. Nor can they see the full tragedy of their inter-linkage. By grasping the stick and/or shoulder of the others, each knows that there is someone who immediately proceeds and/or immediately follows him. What each does not know is that there is an inter-linkage with each of the others in the scene, and that all are about to fall together, like dominoes, into the ditch.

In short, Bruegel's painting, *The Blind Leading the Blind*, allows us to see "something more" or, we might say, to see a familiar story with greater depth. Well known to people of Bruegel's day, just as it is to many of us today, the parable was first told by Christ in *Matthew 15: verse 14*, "If the blind lead the blind, both shall fall into the ditch". Other painters had also depicted the parable and, in an earlier color plate, Bruegel himself had presented a design of it (although some scholars attribute this work to Hieronymous Bosch). Moreover, as we saw earlier, Bruegel

also painted the morality of "falling" into other works, such as *Fall of the Rebel Angels* and *Landscape with the Fall of Icarus*. But in *The Blind Leading the Blind*, instead of being "merely" a theme of the painting, falling dominates every aspect of it. Aesthetics and subject matter are inextricably interrelated. The theme of the subject is relentlessly pursued. We already mentioned the inter-linkage of the six figures. A close look at the eyes of the six shows that each is progressively more blind than the one who follows. Moreover each figure is more hunched over than the one before it, so that our eye is drawn from left to right, until it stops at the ditch. In this immensely compelling painting, Bruegel depicted the moral lesson of falling by carrying it to its logical conclusion of inevitably falling.

Just like the viewers of Bruegel's day, we too know that the parable of the blind leading the blind is not simply about blind people. From the Biblical context, it is quite clear that Christ was thinking of the Pharisees, the religious establishment of ancient Israel, as the blind. By extension, in our world of imperfect knowledge, governments and other organizations are full of people with sight who do not "see," and the more we realize this, the more we feel the enormous power of this profound painting. Looking at it in Naples, I couldn't help but reflect on how people can continue to live there with the knowledge that Mt. Vesuvius could erupt again some day (along with the blind hope it will not). But, then again, people build homes on the fault lines of earthquakes or the edge of shore lines of oceans, knowing full well that earthquakes will happen (someday) and that sea levels will rise (someday), all the while hoping that these catastrophic events will not occur.

Much as we can be blind to the natural tragedies that are about to befall us, so can we be naïve about being misled by our leaders. The parable resonates with the medieval myth of the Pied Piper, whose eerie sounding flute led the rats over the cliffs. It also resonates with the feelings of all who have worked for a boss who seemed to have no idea of what s/he was doing. It resonates in our feeling of

unease concerning social policies pursued by our leaders, even if we acquiesce to them. The iterated parable is especially evident in the chain of command in the military. Soldiers fight because they are ordered to do so by non-commissioned officers who, in turn, are ordered by commissioned officers, whose efforts are coordinated by generals responding to the often ill-conceived ideas of our political leaders. The parable is also at work in the feelings of investors, such as those of the 1990's, who believed the rhetoric promoted by stockbrokers, analysts and innumerable "experts" that stock markets could only go up. The list could go on and on, but suffice it to say that in *The Blind Leading the Blind*, Bruegel succeeded in putting a key metaphor of our human condition onto canvas in such a way that we can truly appreciate it for what it is.

The Blind Leading the Blind is so engrossing that one is tempted to overlook *The Misanthrope* that hangs right beside it. (See Plate 29.) It certainly is a painting that is much more difficult to interpret and appreciate. Dated 1568, the same year as *The Blind Leading the Blind*, which also was the last full year of Bruegel's life, it is considerably smaller than its neighbor (the same width but only half the height). The colors lack the subtle luster of those in *The Blind Leading the Blind*. A stark black and gold stand out. To be sure, the scene is pastoral, with a shepherd and four sheep in the distance. But the relationship between the two main characters is unclear. It appears that an old man has turned his back against a boy who is "relieving him of his purse," and is encircled by a globe with an off-kilter cross at its top. Finally, the message, "Because the world is so unfaithful," written in sharp Flemish lettering at its bottom, is so obscure that one has to wonder what it means.

On a superficial level, I should have been prepared for this painting, because its main action depicts a man having his purse snatched. This is exactly what happened to me only a few days earlier while riding the Metro in Rome. Having

my pocket picked was a new experience, and I felt the compromise and violation that are typical of victims of crime. I also felt a sense of natural justice when I realized that the thief, whom I never saw, had picked the wrong pocket. He took my reading glasses instead of my wallet; I hope he put them to good use!

Actually, *The Misanthrope* needs a second look. It is not really about having one's pocket picked. Rather, its written message of unfaithfulness comes from Flemish folklore. While well known in Bruegel's time, the adage is little used today, even if unfaithfulness is still with us. Although framed in a square, the actual painting is round, suggesting that the old man, possibly a miser carrying the fat purse attached by a strap or cord, and the shabbily dressed boy encircled in the globe, are both part of the same world. To viewers of Bruegel's day, the upside-down slightly tilted cross would have suggested wickedness. All of this has led some interpreters to see *The Misanthrope* as depicting the wickedness of a young street urchin casually relieving a poor, victimized old man of his life savings.

But just a minute! Seeing the boy as the wicked perpetrator and the old man as the unwilling victim of purse snatching doesn't quite jibe with the meaning of the written message, "Because the world is so unfaithful..." The problem is that the bearded old man dressed in black, the traditional color of mourning, has turned his back to the world, and appears to be walking away, perhaps not even realizing that he is about to step on the spiny star thistles that lie in his path. Could it be that he is a hypocrite for going into seclusion with a full purse? If so, does he somehow "deserve" to have his money stolen because he won't need it anyway? The poignancy of these moral questions is heightened because Bruegel has set the action of the painting in a serene, bucolic landscape.

One can go even further with the morality of the situation by looking at the smaller figure, a shepherd, who is somewhat in the distance. Is he the "good shepherd," who tends his sheep? If so, his being part of the scene contrasts to the

essential wickedness of *both* the old man, who has taken his money and run from the world, and the young boy, who is taking that very same money. If we think of the painting in its entirety, all three figures in it are encircled, suggesting that they are, like the six blind men in *The Blind Leading the Blind*, inter-connected in a common world.

Much in the spirit of Montaigne, the travel to Rome and Naples allowed me to see Bruegel's art in new ways. While I thought he had missed the aesthetic of the city of Naples in his painting, *A View of Naples*, his use of the ancient structure of the Coliseum as a symbol for the Tower of Babel was a stroke of genius. With it, he had captured not only the "soul" of Rome, but also the something of the soul of western civilization.

Moreover, the two Bruegel paintings that hang at the Capodimonte Museum in Naples are superb examples of his art. Actually seeing *The Blind Leading the Blind* with its detailed background setting, its substantial size, its grayish blue hues, and its graphic portrayal of inter-linkages among a group of people, allowed me to appreciate the depth of this well-known piece of folk wisdom that is so well known we often do not stop to really see it. By the same token, *The Misanthrope*, in its depiction of an "evil" old man being victimized by an "evil" young boy (with a "good" shepherd in the distance), all interconnected in a common world, is a wonderful artistic presentation of moral complexity that challenges us today, much as it probably challenged viewers of Bruegel's day. Perhaps it is fitting that both of these paintings, which raise compellingly complex moral questions, should hang today in a city whose "on the brink" character is very much influenced by its everyday life in the shadow of a well-known, potentially explosive volcano.

Chapter 5
From San Diego to Prague, 2001-2004

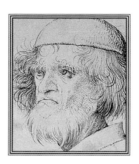

S|| o far, I had been to Madrid, Vienna, Antwerp, Brussels, Rome and Naples and seen the majority of Pieter Bruegel's major paintings in the museums where they hang today. But I wanted to see all of them, even if the remaining works were spread out in diverse cities across Europe and the United States, and even if some were not so well known as those I had already seen. Also, I wanted to understand Bruegel as a painter of things social, especially the multiple aspects of things social that he managed to put on canvas. With this in mind, I traveled over the period of a few years to Berlin, Budapest, Darmstadt, Detroit, London, Munich, Paris, Prague, San Diego, and Winterthur.

In today's world, travel to these far-flung cities is relatively easy. The airplane, of course, has greatly shortened the time it takes for anyone to go anywhere. The cities of Europe are also interlinked by regular, high-speed train service. Of even more importance is the political and economic unity that has come through the European Union. You can go from city to city without passport checks (except for Prague, which was not yet a member of the EU at the time of my trip there). The common currency of the euro greatly facilitates economic transactions.

In sharp contrast to the present, the 16th century Europe of Bruegel's day was very divided both geographically and socially. United mostly through mutual trade, the cities that had risen centuries earlier were considerable distances from one another. Travel between them was relatively infrequent. The nation-states that would bring tremendous change to the political structure of Europe had yet to emerge. The idea of a European Union was totally out of the question. Socially, feudal Europe was nothing less than a combination of five societies, with five different hierarchies, existing side by side: (1) a "seigniorial" society that bound landlord and peasant, (2) a theocratic society promulgated by the Roman Catholic Church, (3) an emerging territorial state headed by would-be kings, dukes and princes, (4) a feudalism that united a vast assortment of lesser nobility in a long hierarchical chain, and (5) towns with their own civilizations and economies, which were interlinked through trade. Looking at this complex social order, Fernand Braudel, the noted historian, concluded:

> This was not one society then but several, coexisting, resting on each other to a greater or lesser degree; not one system but several; not one hierarchy but several; not one order but several; not one mode of production but several, not one culture but several cultures, forms of consciousness, languages, ways of life. We must think of everything in the plural.

The depth of Pieter Bruegel's social perception emerges when we look at his art in terms of each of these five feudal European societies, one at a time.

SEIGNIORIAL SOCIETY

The seigniorial society was one of manors and landed estates that dotted, one might say dominated, the countryside of Europe. For the most part, the estates

were economically self-sufficient and included a manor house for their lords and significant tracts of land. Less visible, but underlying the social structure of the manor, was a set of feudalistic rights held by the lords. These rights, which could include the right of the lord to act as judge in matters of disputes, allowed for varying degrees of freedom and servitude for the tenants or serfs of the land. In any case, it was a world in which the lord and his family differed sharply from that of the tenants or serfs. It is hardly surprising that two distinctly different cultures developed. The consciousness, language, and way of life of the lords were of a much different order than that of the tenants/serfs.

We have already seen the eloquence with which Bruegel portrayed the essence of seigniorial society. It is true that he did *not* paint pictures of manorial houses. Nor did he paint portraits of the nobility, as did other painters who often received significant monies for their efforts. What he did paint, as we saw in Vienna, was a set of five magnificent seasonal scenes that so eloquently depicted the range of occupations in which the serfs/tenants of the seigniorial society were engaged. Moreover, in his genre pieces, Bruegel gave us magnificent snapshots of peasant culture in action. Finally, in *The Poacher*, and arguably in *The Misanthrope*, Bruegel portrayed morsels of the folk wisdom that underlay this society.

Showing the universality, indeed timeliness, of the appeal of Bruegel's art, many of these paintings of seigniorial Europe have gone to places far removed from where they were painted. True, the majority of the paintings are in Vienna, but one will find *The Wedding Dance* in Detroit, Michigan; *The Harvesters* in New York City; and *Haymaking* in Prague. The timelessness of the paintings ran through my mind as the train I was taking left Berlin on the way east to Prague. Barely had it left the city when it wound its way through miles and miles of open, rolling farmland. Emerging from a half-century of communist rule, Eastern Europe is distinctly less developed than Western Europe. Far less visible are the housing

developments, shopping centers, crowded highways or extensive construction that is so characteristic of Western Europe and the United States. But one does see expansive tracts of farmland dotted with people, generally in groups, their parked cars and vans nearby. These workers are modern day tenants/serfs who typically receive low wages and often come from outcast groups such as gypsies.

Theocratic Society

Bruegel could not help but be aware of the theocracy that was the Roman Catholic Church. Throughout 16th century Europe, the church was deeply embedded in virtually every aspect of culture and society. It was the church that employed Latin as its official and only language, that authorized the books to be read (by the relatively few who were literate), and that used the threat of eternal damnation through excommunication to maintain power over the very thoughts the people were permitted to think. The same church dictated the calendar of everyday life, from the masses that were celebrated every Sunday to the holidays and festival days that gave the peasants a break from their everyday labors.

At the same time, Bruegel also must have been well aware of the beginnings of breakdown of the church monolith. In 1517, a few years before he was born, Martin Luther posted his famous 95 theses on the door of a church in Wittenberg, Germany, with its demands that the church change its ways. In 1536, with the publication of *Institutes of the Christian Religion*, John Calvin advanced his doctrine of free will, which put the responsibility for the believer's soul in his or her own hands—a doctrine that would take the Reformation in other directions. Antagonists of the Roman Catholic Church, Protestants as they were called, would subsequently become split into rival factions. Looking back to this period, historians have concluded that the religious fragmentation became so extensive that people stopped talking about a Christendom that once had been unified in

a Holy Roman Empire, and began to speak instead of a "Europe." The once culturally monolithic church that could claim, with divine authority, not only that the earth was flat but also that it was the center of the universe, began to crack. After Copernicus and Galileo, astronomers knew that the earth revolved around the sun. Explorers found that humans would not fall into an eternal abyss when they sailed to far distant places. Mapmakers found that they could map out the planet on which we live.

The breakdown of the power of the Roman Catholic Church was not a peaceful cultural transition. Rather, the church authorities responded with a counter-reformation that would employ any means to restore orthodoxy of belief. Persecution of people in order to force them to recant religious beliefs was very common in Bruegel's day. It was so common, in fact, that it became politicized, one might say, in 1566, near the end of Bruegel's lifetime, when Philip II, the Habsburg King of Spain, sent his infamous ally, the Duke of Alba, to restore the "true" faith to the rebellious peoples of the lowlands. The ferocity of his actions precipitated a bloody war that would last 80 years, and is still remembered today.

Given the fragmentary documentation of Bruegel's life in these tumultuous times, we really know little about where he stood in terms of his religious convictions. While some have argued that he was a Protestant, others have suggested that his sympathies lay with church reformers, such as Erasmus, with whom he may possibly have had a personal contact early in his life. At the same time, it is also known that one of his patrons was Cardinal Antoine Perrenot de Granville, a prelate of the church, who brought the Spanish Inquisition into the Netherlands. Yet, there are still other scholars who have argued that Bruegel was a committed stoic, so deeply involved in his art that he remained rather indifferent to the social turmoil that surrounded him.

Even if we know little of his life, a look at Bruegel's art shows that he was

acutely aware of the religious turmoil in which the Antwerp and Brussels of his times were so involved. No fewer than 14 of his paintings are based on distinctly religious themes. Of the 14, three are based on Old Testament themes and eleven are based on New Testament themes.

When viewed as a group, the 14 religious-theme paintings cover an enormous range of subject matter. Because of Bruegel's ability to combine contrasting sets of ideas in any given painting, each one of the 14 bears its own unique interpretation. Thus, in Vienna, we showed how Bruegel used topsy-turvy perspectives to depict religious themes as diverse as conversion, suicide, crucifixion and the social chaos of language. In Brussels, we saw how, in his *Fall of the Rebel Angels*, he took a different approach by employing touches of realism amidst the grotesque, in order to illustrate the concept of falling. In Naples, in *The Blind Leading the Blind*, we saw how he used iteration and inter-linkage to allow us to see the multiple dimensions of blindness.

As discussed earlier, the key to appreciating Bruegel is to look for the "something more" in any given painting. In his religious paintings other than those mentioned in the above paragraph, Bruegel often conveys the tensions of his times, by inserting either as detail or secondary text a secular or humanistic something more that contrasts, or even contradicts, the dominant religious theme. For example, *Parable of the Sower,* an early work, depicts the New Testament story of *Matthew 13: verses 3-8*, in which seed, a well understood metaphor for the word of God, falls on fertile ground where it bears fruit, or by the wayside, where it is eaten by birds, or on stony ground, where it withers away, or among thorns, where it is choked. (See Plate 30.) The sower casts the seed. The birds eat that which has fallen by the wayside. Harder to see, but still visible, is the crowd of people on the far side of the river, looking to the ship; this represents the subsequent part of the story, that a great multitude gathered together to hear Christ, who went onto a ship

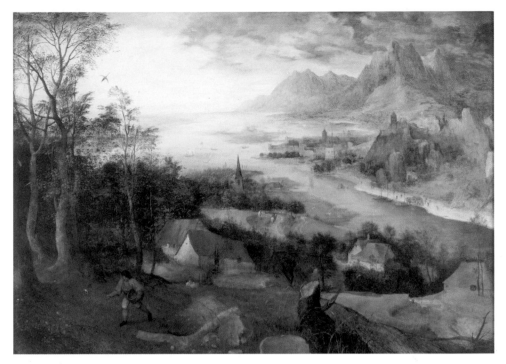

Plate 30: *Parable of the Sower*, 1557
Oil on canvas, 29 1/8 x 40 1/8 in
Timken Museum of Art
San Diego

Plate 31: *Saint John the Baptist Preaching*, 1566
Oil on panel, 37 3/8 x 63 1/4 in
Museum of Fine Arts (Szepmuveszeti Muzeum)
Budapest

and sat as he spoke to them.

The uniqueness of this painting is that Bruegel captured the essence of the parable that was part of the universal Roman Catholic Church and made it unmistakably Flemish. We see the sower in Flemish dress casting the seed. There is a Flemish church spire near the center, several Flemish houses in the forefront, and what appears to be a castle and town in the distance. Close inspection, with a magnifying glass, confirms that the crowd surrounding Christ in the boat is Flemish. You might say that Bruegel articulated or translated this well-known parable of the theocracy of a universal church into the vernacular of Flemish culture.

Bruegel also "Fleminized" *Saint John the Baptist Preaching*, but this painting is more complex, and there are several other pieces of "something more" that make it a very compelling painting. (See Plate 31.) Whereas *Parable of the Sower* presents an idealized landscape, with the "multitude" represented in what are literally dots on the distant shore of the river, *Saint John the Baptist Preaching* is much more detailed and immediate. With its flatter perspective and the crowd placed in the foreground, we as viewers are thrust into the painting. The people depicted appear as real. Nor can we miss the John the Baptist figure, with left hand extended to display his role as forerunner to Christ, who is shown in radiant light blue on his left.

Moreover, the contrasting details are compelling. The crowd is by no means one of true believers, listening in rapt attention to the voice proclaiming the coming of the Messiah. Instead, the two people on the lower right appear to be in deep conversation. The man standing by the gnarled tree on the left seems to be staring into space. Very out of place is the man in the center foreground who, though in a direct vertical line with the Messiah, has his head turned away and is having his fortune told by a gypsy—an act considered an anathema by both the

Old Church and Reformers of Bruegel's day. Interestingly, several scholars of this painting have concluded that this man is none other than Bruegel himself.

The more general point of *Saint John The Baptist Preaching* is that Bruegel portrays people exposed to the message of the coming of Christ who are too preoccupied to hear it. This suggests that the traditional Christianity (i.e., the Roman Catholic Church) of Bruegel's day was losing its ability to command the beliefs and commitment of those who were supposed to have been part of it. It is in this challenge to church authority that we see what we might call a Renaissance, humanist or secular critique of religious orthodoxy.

Notice how this painting becomes rather less interesting if we remove the enigmatic man in the center foreground. This is precisely what happened in what appears to be a copy of this painting by Bruegel's son, Pieter Bruegel, The Younger (1564-1637), which hangs today in the Groeninge Museum in Bruges, a quaint but once important city about 90 kilometers northwest of Brussels. To me, it loses much of its distinctiveness and becomes just another piece of religious art.

While we know by its date and signature that Pieter, The Younger was the painter in the Groeninge, we really do not know why he omitted the enigmatic man. Was it out of some sense of "political correctness" that he did not want to insert a message that could have been taken as critical of the church? Did he reproduce the painting for another patron who controlled what was included on the canvas? Or, perhaps, was it out of deference to his illustrious father that he did not want to copy him down to the last detail?

Regardless of how Pieter, The Younger, copied the work of his father, the various subtexts of *Saint John the Baptist Preaching* have led to years of speculation about it. Some interpreters have used the contradictions incorporated in it to suggest that Bruegel approved of or was, in fact, a member of the Reformed Church, a Protestant group that promoted open-air meetings with much satirical

abuse of Catholic beliefs. Others have suggested a more-likely possibility that Bruegel may have painted *Saint John the Baptist Preaching* as he did because he was part of a circle of Erasmian, anti-clerical Catholics, a break away religious group that also held open-air meetings. However, Bruegel's personal religious affiliation is, I think, not what he was trying to convey. As I look at the painting, to me the point is that there is a divine message, the essence of which is portrayed in it. But no church can compel people to accept the message of salvation, much less prosecute them for not accepting it, however important it may appear to be. That is a matter of free will. Individuals may or may not listen. They may or may not accept it. They may have their own agendas. They may hear one part of the message but not another. No matter what, they are human creatures who can and should make their own moral choices.

Given the subversive nature of this painting, it is an historical irony that *Saint John the Baptist Preaching* has long hung in the Museum of Fine Arts in Budapest, Hungary. The building of the museum is a stone structure that was once formidable but is presently in need of maintenance and upgrading. Men and women who appear to be former functionaries of the now defunct communist state staff the museum. The recorders with their taped messages describing the paintings are old and awkward to handle. To enter the museum is to be gently reminded of the inefficiencies of the once-all powerful East European communist state.

In actually seeing *Saint John the Baptist Preaching*, as I did in Budapest, I somehow felt how it must have challenged the institution of the Roman Catholic Church. At the same time, the painting had been available for public view to those who had lived in the totalitarian, secularized state of communist Hungary. You had to wonder how many of those who viewed the painting during the 1950's and 60's realized that, in the 1970's and 80's, Christian groups would hold religious assemblies and church services in wooded areas on the outskirts

of cities—meetings that would prove to be a factor in the disintegration of the communist empire. Of course, we cannot say that Bruegel's painting was a causative factor in the breakup of the communist empire or, for that matter, in the breakdown of the Roman Catholic Church that would eventually occur. What we can say is that Bruegel vividly painted the many, at times contradictory, sides of our religious experience. He pushes us to the realization that, at the same time we seek the certainty provided by large, powerful, well-established religions, such as Roman Catholicism, we also want the freedom to think for ourselves, to rebel, and to do things our own way.

Parable of the Sower and *Saint John the Baptist Preaching* are similar, in that each places a Biblical story of the New Testament in a Flemish setting. At the same time, they differ markedly in that, while the former portrays an idealized world, the latter puts forth a Renaissance humanism that belies the apparent meaning of the painting. Given these rather different perspectives on well-known Biblical stories, is it more than a coincidence that the two works today are at opposite ends of the world, defined by the cities where Bruegel paintings are on display. Now in the Timken Museum of Art in San Diego, *The Parable of the Sower* is the painting that has "traveled" the furthest from Antwerp, where it was originally painted. *Saint John the Baptist Preaching*, although closer to Brussels, hangs in the city that is furthest to the east. Again, the universal appeal of Bruegel's art impresses us. If the idyllic *Parable of the Sower* is on show in sunny Southern California, perhaps it is fitting that the provoking, reflective *Saint John the Baptist Preaching* finds itself in Budapest, a once glorious city that is only beginning to find its way as part of the new global order, after decades of repression under Nazi and Communist governments.

Bruegel took yet another perspective on the theocracy of Roman Catholicism when he painted the theme of the adoration of kings. He did this in two strikingly

different renditions of the same Biblical story. Told in the New Testament Gospel of *Matthew, Chapter 2, Verses 1 through 12*, the story is the well known one of the wise men following a star, as they went from the East to Jerusalem, so that they could recognize the newborn Jesus. In *The Adoration of Kings in the Snow*, the essence of Bruegel's perspective is that the events took place in the context of a typical Flemish town. (See Plate 9 in the Vienna Chapter.) Indeed, Bruegel used the typical Flemish town as a backdrop, a technique he employed in *The Massacre of the Innocents* and *The Census at Bethlehem,* as well as other paintings. In the scene, Mary shows the newborn to the Magi, two of whom kneel before her. Joseph lurks in the background. In the road that runs through the center of the painting we see the animals and people that compose the company of the wise men. In the foreground, townspeople are at work carrying on their trades.

What makes *The Adoration of Kings in the Snow* most unusual is the snow itself, which is not simply on the ground, as it is in several other Bruegel paintings, but is actually falling. Bruegel's depiction of snow in this manner makes us look at the whole scene rather differently. The falling snow blurs the people, the animals, and the activities depicted, so that we are left with a sense of mystery, one might even say awe. The mystery deepens when we realize that, even today, we really do not know who the wise men were, from where they came or the full reason they came. Although they are recorded as being present immediately upon the birth of Christ, they are never mentioned again in the Biblical narrative.

Bruegel's other painting of the story of the adoration of kings, *The Adoration of the Kings*, employs a totally different perspective. (See Plate 32.) Once again he has Fleminized the whole scene, but this time one gets the impression that the kings are very human; indeed, they are earthy. They are in a manger, its stone floor supported by rough-hewn wood beams. The onlookers are dressed in Flemish costumes; the characters (with the exception of the Moor on the right side) have

distinctly Flemish faces. Moreover, the mystery of the story is told through the
expressions on the faces of the onlookers. The two kings kneeling before the baby

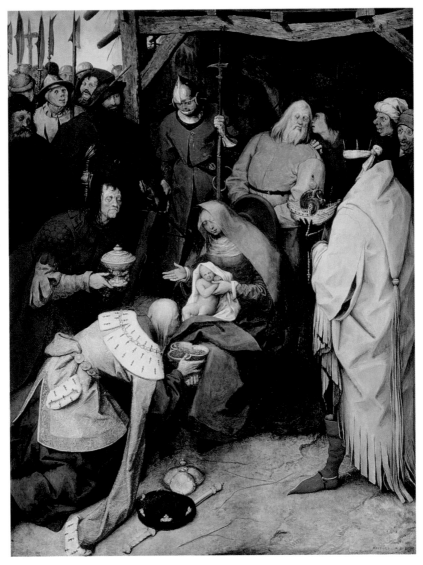

Plate 32: *The Adoration of the Kings,* 1564
Oil on canvas, 43 3/4 x 32 7/8 in
National Gallery
London

Jesus appear old, weathered, as if they could not comprehend that this child would presage a new realm of social order. There is also a sense of bewilderment on the face of the third king, whom Bruegel portrays as a Moor.

Perhaps the most distinctive twist of this painting is the seemingly smart-aleck boy whispering into Joseph's ear. Bruegel's inclusion of the boy highlights a non-Biblical part of the adoration story, widely known to people of his times, in which Joseph reportedly doubted Mary's purity, and thereby questioned the very notion of the virgin birth. The extra touch provides a contrasting, humanistic, indeed secular perspective through which to view this otherwise religious painting.

Today, Bruegel's two renditions of the adoration of kings are hung in places that are rather distanced in time and place from where they were created. *The Adoration of Kings in the Snow* is part of the impressive collection of paintings at Winterthur, in Switzerland, while *The Adoration of the Kings* is in London, England. While the former is today a modern resort town in the Alps, the latter is a seat of power that has been home to British monarchs for more than a millennium. It is, I think, fascinating that this painting, which portrays adult secular kings bowing to a baby king of a very different order, should hang in a city where monarchy continues to thrive.

EMERGING TERRITORIAL STATE

Bruegel lived in a time when the nation-state as we know it today was only beginning to emerge. As we saw earlier, much of everyday life in the seigniorial society of his day took place on economically self-sufficient landed estates. The right of the lords to govern the estates was granted by various royal families of Europe. In particular, members of the Habsburg royal family enjoyed what they regarded as personal holdings of land that covered vast areas of Europe, as well as South America. In that they controlled the right to use force in these territories,

their land holdings were, in effect, precursors of the nation-state as we know it today.

His genius at putting "something more" into his paintings allowed him to provide a social critique of the emergent nation-states. We observed in Vienna how he inserted the not too subtle message of the state as persecutor of innocent people exercising their right to religious belief, when in *Conversion of Saint Paul* he painted a central figure, widely known to represent the notorious Duke of

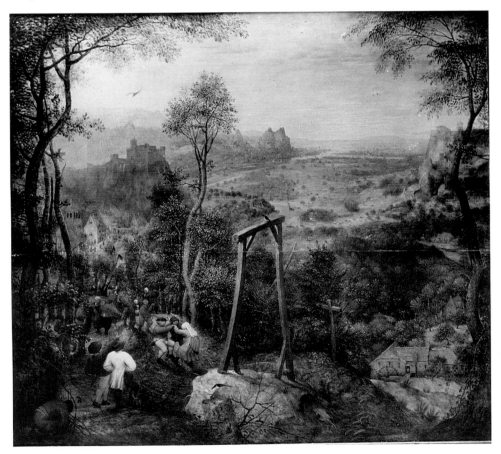

Plate 33: *Landscape with Magpie on the Gallows*, 1568
Oil on panel, 18 1/8 x 20 in
Hessisches Landesmuseum
Darmstadt

Alba, leading Christians to their punishment. By the same token, the entire army escorting Christ to the cross in *The Way to Calvary* is dressed in red tunics, widely known as Habsburg's colors.

Bruegel's most biting social critique is, I think, in his *Landscape with Magpie on the Gallows*, a painting that may seem quaint but is, at the same time, haunting, mysterious and sharply critical of the social powers of his day. (See Plate 33.) Probably his last work, it is at first glance a quintessential Bruegel. It depicts a scene of serene beauty, an exquisite landscape that includes sky, mountains, a meandering river, meticulously detailed trees, and the buildings of a town. Amidst the landscape is a scene that clashes almost violently with its beauty. We can hardly miss the gallows and the cross long used for carrying out executions. A bird, most probably a magpie, sits atop the gallows. If we look at the people we see three to the left of the gallows who are dancing. There is also another group in the background, who could possibly be on some type of outing. The sharpest contrast to the natural beauty is the peasant in the lower left corner, who is doing nothing less than defecating. What is going on here?

In this striking painting, with its clashing themes, Bruegel is asking us to see the world through the lens of two Netherlandish proverbs well known in his day. Most prominent is the proverb that "shitting" and "dancing" on the gallows are ways of mocking and laughing at the power of the state. But, no less important, is the secondary proverb, which gives the painting its awkward sounding title. It is that magpies were pictured as gossips and people were hanged because others gossiped about them.

In short, *Landscape with Magpie on the Gallows* is a painting that sharply critiques social authority. The painting is surrounded in mystery because we know neither for whom nor why the work was painted. Also, because Bruegel left no writings about it (or, for that matter, about any other of his paintings), we have no

idea what he might have been trying to say in this enigmatic painting. Yet, we do know it was painted in 1568, the year that saw the beginning of a bitter war that would last 80 years, during which time the Spanish would attempt to subdue the people of the lowlands (modern day Belgium and The Netherlands). We also know that 1568 was the last full year of Bruegel's life. Moreover, there is an anecdote (as reported by Carl van Mander, who wrote in 1604, 35 years after Bruegel's death), that fearing trouble with the Spanish authorities, Pieter asked his wife Marianne to burn this painting upon his death. Thank goodness for us that she did not comply with his wishes!

Bruegel's choice of the gallows as the focus of this painting is poignant, because public executions served not only as a means of punishing criminal behavior but also as a demonstration of the power of the state over life and death. Thus, the point of "dancing" and even "shitting" on the gallows was not to condone criminal behavior but to challenge the power of the state, especially the injustice of its administration. The symbol of the magpie speaks further to the question of injustice because convicting and hanging people on the gossip of others, rather than using evidence, is clearly wrong. Indeed, in looking at the magpie, it should be remembered that witchcraft was practiced in the Europe of Bruegel's day.

It was not until the late 1700's that European countries would see reform movements that would curtail, and eventually eliminate, use of the death penalty. In part the penalty itself came to be seen as cruel and barbaric. Many in the community were simply disgusted by the gruesome spectacle of seeing a live person put to death. But another part was that its public use began to backfire. Some of those about to be hanged refused to give the customary speech, in which the convicted person was supposed to repent for his or her crime and ask for forgiveness. In some cases crowds are known to have attacked hangmen, especially if they felt they were carrying out a wrongful sentence. It is impossible

to know whether *Landscape with Magpie on the Gallows* had any role in these subsequent developments concerning the use of the death penalty, but what can be said is that, once again, Bruegel provided a lens through which to view a morally problematic aspect of our social life.

Given its unusual themes, *Landscape with Magpie on the Gallows* is not to be seen as simply "another great Bruegel." When I first came upon it in Darmstadt, Germany, I felt that in a Europe, which had long since abolished the death penalty as a cruel and barbaric punishment, the painting had somehow been marginalized, removed from Bruegel's other works and placed in a provincial city south of Frankfort far from Berlin, the major center of German culture (with two other Bruegel paintings). But, a year later, while on a hiking trip in Germany not far from Darmstadt, we came upon a tree in the countryside which, our guide informed us, was often used for hanging "criminals" and those who went "too far" in challenging the authority of the state. Perhaps the painting's location in Darmstadt is a gentle reminder that, while the locus of the power of the state is often in a major capital city, the abuses of that power may well be felt by those who are in distant countryside places.

Out of Europe, this very unique painting contains a social message that has a remarkably contemporary ring to it. In the United States (and many other non-European countries), questions of whether or not to use the death penalty, and how much publicity should be given to its use, continue to be debated. If we reflect on these issues as we examine *Landscape with Magpie on the Gallows*, we get a sobering reminder that the mere threat of the death penalty does not simply cow everyone into submission. In fact, its overuse, its unjust use, especially against minorities, may well serve to undermine the authority of the nation state.

TOWNS

Having seen how Bruegel's art captured so much of the essence of seigniorial

society, theocratic society, and the emerging territorial state, it is almost disappointing to say that there is one of the five societies of medieval Europe that Bruegel did not really paint, namely the feudalism represented in the assortment of lower nobility. Again, we are in the dark as to why. On the other hand, he certainly did incorporate the fifth society, namely the towns with their own civilizations and economies interlinked through trade.

Basically, towns are little more than a collection of buildings in a given territorial area where people live in close proximity to one another. In the Middle Ages they were often surrounded by walls. Economically they are unique in that their inhabitants live primarily off trade and commerce rather than agriculture. By their very nature, towns give rise to ways of life that are often very unique. In fact, there is a long line of thinkers who have regarded towns (and their more complex forms, cities) as embodying the very essence of Western civilization.

Bruegel undoubtedly was intimately acquainted with town life. It is believed that he came from the town of Brueghel, no longer existent, but near the modern day city of Breda. Indeed, it is thought that he took his name from the town (although he changed the spelling to Bruegel later in his life, as mentioned earlier). He would, of course, also have known something of the ways of town life because his adult years were spent in the cities of Antwerp and Brussels. It should also be said that, with the periods of economic growth in the lowland countries during his lifetime, towns were on the upswing economically, and were places to which increasing numbers of people were drawn. Indeed, we have already seen how he brought diverse perspectives on town and city life in portraying the under-life of the town in *Mad Meg* (see Plate 21) and the sense in which the civilization of the town can trap us in *Two Chained Monkeys.* (See Plate 20.)

But Bruegel also captured the essence of town life in several other ways. Take, for instance, the rather odd painting known as *The Beggars* (also known as, *The*

Plate 34: *The Beggars*, 1568
Oil on panel, 7 1/8 x 8 1/2 in
Louvre, Inv. RF 730
Paris

Cripples.) (See Plate 34.) It is his smallest work, only 7-1/8 by 8-1/2 inches, and a far cry from his majestic landscapes, even if it is dated the same year, 1568, as *Landscape with Magpie on the Gallows*. Absent is complexity of detail. Although there is some depth perspective, the figures are very much up in front, set out for us to see. Like some of his other works, we simply do not know why he painted it. Nor for that matter is it clear who would have been a supporting patron. What we do know from the painting itself is Bruegel's willingness to depict people who would be considered marginal to their society. Interestingly, he placed the beggars

in the setting of a town because, marginal though they may be, they were a part of town life.

Looking at *The Beggars* through modern eyes, we might think that Bruegel painted the work to evoke sympathy for the marginal people of his day. This interpretation works if we identify with the beggars by feeling sorry for their plight and see them as forced into beggary in order to survive. However, there is also a completely different interpretation. Historical research suggests that Europeans of Bruegel's time had little sympathy for beggars, even if they were also cripples. From this perspective, the wall in the background of the painting is the outer wall of the town, thereby placing the beggars (cripples) on its fringe.

The latter interpretation is supported by the details of the painting. The kneeling figure on the right, with back toward us, is covered with foxtails, a symbol of ridicule that was used in political satires in Bruegel's day. Indeed, each of the five figures portrayed in the foreground is pathetic. Each engages in mock dances. One is faceless. The foxtail bearer is backward. The man on the left covers his eyes with his hat. The one in the center wears bells on the stumps of his legs—a sign that he (and by implication, the others) are little more than entertainers or jesters, who typically take to the streets during carnival times. That said, perhaps the most intriguing figure is the old woman in the rear on the right. We do not know whether she is nurse or mendicant nun, but it appears that she has brought no food. Indeed, she too has turned away, uninterested in and indifferent to the plight of the beggar/cripples.

However one interprets *The Beggars*, the painting portrays a moral dilemma, both of Bruegel's time and ours. Should the socially or physically handicapped be "mainstreamed?" Should they be blamed for their condition, and told that they have to "deal with it," or do we sympathize with them and offer them special consideration? Are they people who need to be "controlled" by the police or

people who need to be "serviced" by some kind of welfare agency? Whatever our answers, we see that, small though its size may be, *The Beggars* is anything but a mere depiction of a slice of life in a town. Hardly quaint, *The Beggars* depicts a scene that causes us to reflect about others in the community who may be very

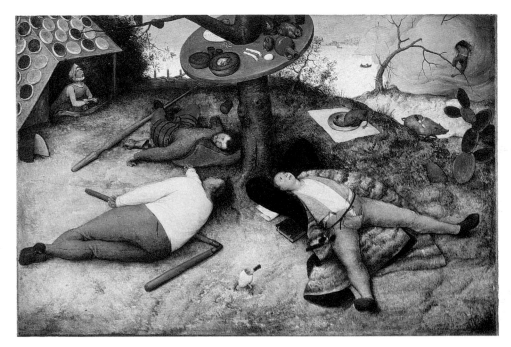

Plate 35: *The Land of the Cockaigne* (Land of Plenty), 1567
Oil on panel, 20 1/2 x 30 3/4 in
Alte Pinakothek
Munich

different from ourselves.

Bruegel took still another perspective on the emerging culture of the town when he painted *The Land of the Cockaigne*. (See Plate 35.) It depicts a well-known European folk myth, of working people, which has its origins in antiquity. The myth is of a dreamland that is a secularized version of the Garden of Eden. In Cockaigne, work was forbidden. Food came to everybody, fully cooked and ready

to eat. Drink of all types was there for the asking. One had only to open the mouth. In this mythical land, the season was eternally Spring. There was also free sex with ever-willing partners, a ever-present fountain of youth, and beautiful clothes to be worn by all. One could even earn money while sleeping.

The depiction of Cockaigne may appear simplistic but it is actually subtle, indeed dreamlike. In the painting Bruegel's focus is on the food aspects of the myth. One can't miss the foods, including poultry and pig, all of which are cooked and ready to eat. They are, you might say, the artistic predecessors of our "fast food." Nor can one miss seeing the knight on the upper left side, who sits ready to eat the pancakes as they slide off the roof into his mouth! There is also what appears to be a sausage falling from the table toward the fellow on the top center left.

Lines of perspective are used to accent the subtleties portrayed in *The Land of the Cockaigne*. The soldier, the peasant, and the clerk who are sprawled out beneath the table form a very clear triangle, while much of the remainder of the painting is of circles, which can be seen in the table mounted on the trunk of a tree, the pancakes, the bellies and rotund bodies of the figures, and the hill or plateau of the ground on which the figures lie. Thus, while the triangle connotes perfection or the ideal, the circle conveys the sense of the continuing wheel of life. In this case, the wheel may be one of a satiation that we all dream of but rarely, if ever, attain.

While not explicitly portrayed in the painting, the culture of the town is illustrated through the perspective of universality that Bruegel built into *The Land of the Cockaigne*. Each of the three central figures lying prone, as the good life is enjoyed, comes from a different walk of life. On the top of the triangle is the soldier, who has cast aside his metallic glove. Below him, the peasant lies on his reaper. Next to him is the clerk, his ledger on the ground. In the feudal society of Bruegel's day, each of these fellows would have lived in a different, specialized

social world. But in being brought together (in the culture of the emerging towns) through living the dream of Cockaigne, they clearly have much in common.

Today, we live at a time when we are close to having attained what the European workers of the 1500's could only dream about. Fast food is available everywhere for immediate consumption. Material objects of almost any kind can be purchased right off the shelves of stores. Sex with willing partners is greatly facilitated by drugs that increase potency as well as those that decrease chances of pregnancy. Everyone has the clothes they need. Monies in our accounts accumulate interest and dividends even on holidays. Nevertheless, we still continue the dream of a society where the need for work is lessened. Who doesn't seek shorter working hours? Who doesn't seek earlier retirement? Even with our abundance of material goods, who doesn't dream of being supported in the "lifestyle to which we have become accustomed?" Is it any wonder that Bruegel's dreamland painting, *The Land of the Cockaigne*, continues to pique our imagination?

In 2004 Vincent Desiderio, a contemporary abstract painter who shifted to the old master style of painting in the late 1980's and went on to produce a painting that was inspired by Bruegel's *The Land of the Cockaigne*. He titled his painting *Cockaigne* and referenced Bruegel's inspiration. But Desiderio visualized Cockaigne not as gluttony but as "cultural bulimia," namely, our compulsive consumption of images that only makes us hungry for more. In a 13 foot by 9 foot work of art that took him 10 years to complete, Desiderio pictured hundreds of illustrations, perhaps more than a thousand, from his own books of art, which were open and spread out on the floor of a room. Featured in the top center of the enormous painting was a table on which the remains of a meal were strewn. One could not miss the parallel to Bruegel's *The Land of the Cockaigne*, nor could one miss the parallel between the bulimia of images and the gluttony we normally associate with food. Taking a further cue from Bruegel, the table and virtually

everything on it were circular, although the books with their illustrations were, of course, rectangular.

When I went to see *The Land of the Cockaigne*, I gave little thought as to why this painting might hang today in Munich, Germany. However, it is said that no visit to Munich is complete without eating (and drinking) at its famed Hofbrauhouse. So, after seeing the painting, my wife and I decided to spend an evening there. It was, to say the least, "memorable." You sit at large communal tables with people from other walks of life, whom you meet for the first (and probably the only) time. The place is alive with the rhythmic music of the oompah band. You eat all the wurst and sauerkraut that is served, even if it looks like more than you would care to consume. You drink beer in oversized steins which, given the conviviality of the atmosphere, goes down so easily that you can readily lose count. Hearty waitresses carry enormously large platters of food and no fewer than ten large steins of beer at a time, five on each arm, to serve you. Indeed, it is not too long before you can appreciate why Bruegel put circularity into his painting of gluttony. And, by the end of the evening, you can understand how wonderful it is that, in the very same city, you can both appreciate the aesthetics of gluttony depicted in *The Land of the Cockaigne* and experience gluttony just as far as you would like to go.

Bruegel caught the emerging culture of the town simply by using the town square as the setting for a number of his paintings. As we saw earlier, his abstract realist paintings of *Children's Games* and *Fight between Carnival and Lent* (Plates 14 and 15) use the "typical" Flemish town square as a backdrop against which to portray their complex themes. A very similar town square also provides the setting for the theological paintings of *The Census at Bethlehem*, *The Massacre of the Innocents*, and *The Adoration of Kings in the Snow*. (See Plates 8, 25 and 9.) Likewise, his genre painting of peasant life, *Peasants' Dance*, is also set quite appropriately in a town square. (See Plate 16.)

But there is one painting set in a town square that stands in a category of its own, namely his *The Netherlandish Proverbs* (also known as *The Flemish Proverbs*). (See Plate 36 inside back cover.) Like *Children's Games* and *Fight between Carnival and Lent*, it is in an abstract realistic style. However, in this painting with its background Flemish town square, Bruegel did nothing less than to put onto canvas the entirety of the Flemish folk culture of his day. To put it another way, in *The Netherlandish Proverbs* he took a complex culture and enabled us to see its soul, its very essence.

The conventional definition of culture used by many social scientists today is "the way of life of a people." Culture is usually broken down into other abstract terms such as "values," "norms," "sanctions," and "social controls." However, when we try to get specific about the nature of culture or to say something about a particular culture, we can easily get lost if we try to describe its nature. For example, if you follow the news, read magazines or examine books, you will find American culture described variously as one or more of the following: democratic, capitalistic, Puritanical, religious, based on merit, materialistic, free-speaking, opportunistic, compassionate, self-centered and corporate. Most of us would, I think, be hard put to find one, or even two or three, themes that underlie its diversity in such a way to explain the true nature of the United States.

The Flemish culture of Bruegel's day was also complex. It was especially rich in the proverbs, adages and sayings that composed the folk wisdom of everyday life. Bruegel was fascinated with this folk wisdom. Earlier in Vienna we saw his painting of the poacher, who is caught up in the dilemma of who has the knowledge versus who is the robber. (See Plate 19.) In Naples we saw his powerful painting of the well-known Biblical adage that the blind lead the blind. (See Plate 28.) And in Darmstadt we just saw his painting of folk wisdom as a challenge to authority, as people danced and defecated on the gallows. (See Plate 33.) But the genius of

The Netherlandish Proverbs is that, in it, Bruegel brought together a representative collection of images that embodied so much folk wisdom that, when you look at the painting, you experience in one glance the entire essence of Flemish culture of the 16th century.

The painting depicts no fewer than 119 proverbs, by presenting them as actions in which people are engaged. (See Appendix 2 for a listing.) The diversity is enormous. Included are references to proverbs or adages that we have seen depicted in other paintings. For example, the roof is covered with dough cakes from the Land of Cockaigne (#1), the notion of the topsy-turvey world is shown as an upside down globe (#12), and scorn is seen as a man, with bottom out of a window, as he prepares to defecate on a globe representing the world (#11). Yet there are also many that do not appear in other paintings, from the quaint "old roofs need patching" (#17) to the obscure "wear a lid on the head" (#28). Like *Children's Games*, *Netherlandish Proverbs* invites the viewer to search for the one she or he likes best or that captures a particular sentiment most aptly. My own favorite is "big fish eat little fish" (#90), which flashes through my mind whenever I think of the competitive quality of our lives today.

The genius of the painting lies in the manner in which Bruegel brings together these diverse bits of wisdom. The background of *Netherlandish Proverbs* can be compared to a modern day theme park. To be sure, there is something of a town square. But there is actually a complete idealized town with a tower, a house (actually two, one in the foreground that doubles as a place of work, and one in the distance), shops, a baker's hearth, and even an outlet to the sea. Moreover, the town is fully populated with trades people, workers who ply various crafts, a butcher, and a baker (although no candle-stick maker). But the people do not act as we might like or expect them to act. Some are fools. Some are scoundrels. Some scorn the world while others bang their heads against the wall. In short, this

town/theme park is nothing less than a world of its own, full of real people, each doing his or her "thing," and each expressing some aspect of what it means to be human.

It takes a second or third look at this painting to see how it portrays the interconnectedness of people and surroundings; in other words, how context and activities interplay to produce culture. Experts have spent years analyzing *The Netherlandish Proverbs*. Most recently, Mark A. Meadow has concluded that the 119 proverbs are clustered into certain themes. In the bottom right, for example, the proverbs "to make your way through the world, you must writhe" (illustrated by the man crawling as if he were a snake into the globe) (#60) and "make the world dance on his thumb" (illustrated by the young nobleman who seems to exude so much power) (#58) express our concern about human stature in the world. The former expresses humility, the latter self-confidence. In other proverb clusters, we see "throw money in the water" (illustrated by a spendthrift nobleman) (#92) not far removed from a somewhat contrasting "cast for a cod with a smelt" (illustrated by the fisherman doing so) (#70). This subtle clustering allows the eye to experience a sense of coherence as it wanders through this virtual reality of Flemish culture.

Another commentator, Wolfgang Stechow, has seen the activities depicted in the painting through the colors that are used to portray them. He argues that Bruegel has employed blues to indicate betrayal and cheating and reds to indicate sin and impudence. Following this logic:

The blue, foolish, topsy-turvy world is predominantly displayed on the left; a red scoundrel drastically expresses his contempt of it (i.e., the fellow with his posterior protruding over the window ledge); the Netherlandish word *verkeerd* stands for both upside down and wrong. Christ, in a blue garb, is the victim of treachery and

folly of a monk who has put him on a red chair, and mocks Him by putting a flaxed beard on him (see lower center right).

Juxtaposing reds and blues in this manner dramatically conveys Bruegel's view of mankind as "endlessly involved in foolish actions."

Following Stechow, it might be tempting to conclude that the inner balance of this painting lies in the fact that it is organized around the theme of folly. Indeed, we have already seen how Bruegel incorporated folly into other paintings. Folly is certainly a theme of *The Netherlandish Proverbs*. If you focus on "the topsy-turvy world" seen in the upside down globe on the middle left (#12), or "she's dropping a blue coat on the husband" (in other words, cheating on him) (#63), or "throwing money into the water" (#92), you could say that folly is what the painting is all about.

However, one cannot capture the essence of culture simply by calling it folly. To begin with, many of the proverbs in this painting illustrate behavior that is morally neutral rather than praiseworthy (meritorious) or blameworthy (folly). For example, regarding #1, would it necessarily be folly to enjoy a land of Cockaigne, whose house roofs are covered with dough cakes? Regarding #2, to marry under a broomstick may not be socially acceptable, but many people have done it and enjoyed life thereafter. Regarding #5, accepting a challenge, especially the right one, is anything but folly! Another problem with the "all is folly" viewpoint is that many, if not most, of the proverbs have multiple meanings—some of which may be quite serious. Sometimes, we use irony or humor to turn a proverb and give it a meaning that is the opposite of its initial appearance.

The Netherlandish Proverbs is a virtual map to 16th century Flemish culture. We usually think of maps as portrayals of our three-dimensional world on a two dimensional scale. Indeed, it was projection maps, the work of the Flemish

cartographer, Gerardus Mercator (1512-94), with their grids of latitudes and longitudes, which first appeared in 1569, and allowed people to understand the world in new ways, and to greatly facilitate navigation of it. Moreover, barely a year later, another Flemish cartographer, Abraham Ortels (1527-98), Bruegel's friend and the person who would later eulogize him, developed and marketed the first modern atlas, a collection of maps published under the title *The Picture of the World*. When marketed, the atlas would find its way into numerous libraries and homes, thereby greatly spreading literacy about the geography of the world, as it was known in those times.

In his map of Flemish culture, Bruegel takes as points of reference the inner meaning of the proverbial folk wisdom of his times. As we have seen, mapping (or depicting) the inner meaning of the folk wisdom of a given proverb is by no means straightforward, especially since any given proverb can be understood in a number of ways. It is mind-boggling to go beyond that and conceptualize how to portray 119 proverbs on a single canvas 46 inches high by 64 1/4 inches wide. But in *The Netherlandish Proverbs* Bruegel goes deeper, giving us the dynamic diversity of an integrated whole culture. His map of Flemish culture has no fewer than 119 points of reference interconnected in some ways by theme and in others by color, and all set against the background of a representative Flemish town. In that culture is the "way of life of a people,' something we live but do not normally see, Bruegel's *The Netherlandish Proverbs*, lets us see Flemish culture by capturing its soul on a painted canvas.

Given that Bruegel's *The Netherlandish Proverbs* is such a masterful portrayal of the Flemish culture of the 1500's, it may appear incongruous (and a disservice to the city in which he lived and worked) that it should hang today, not in Brussels but in Berlin. However, a trip to Berlin in the summer of 2002, to its Staatliche Museum, led me to better understand the universality of the painting, and why it is

meaningful for the culture of our global order today.

In Bruegel's day Berlin was relatively "young," as cities go. Unlike many other German cities, it does not date back to Roman times. Rather it was founded in 1307, when two Slav settlements on the opposite sides of the Spree River were united for defensive reasons. In 1359 it joined the Hanseatic League of Northern European cities that were linked through trade. In 1486 (40 years prior to Bruegel's birth) Berlin was chosen as the seat of the royal residence for the Hohenzollern dynasty. In the 1700's this dynasty would emerge as the most powerful state of the German Empire. Although it experienced turmoil between 1806 and 1808, when it was occupied by Napoleon's forces, and during 1848, when it was the center of Germany's March Revolution, Berlin flourished after 1871, when it became the imperial capital of the German Emperor. At the same time, the industrial revolution brought explosive population growth as workers flocked to its factories. It also emerged as a world cultural center. Its magnificent Kurfurstendamm, a boulevard commissioned by the great 19th century chancellor, Otto von Bismark, is lined with buildings that were built in the grand style of those times.

The city of Berlin became deeply involved in the major events of the 20th century, when Adolph Hitler selected it for his base of political power in 1933. It was from Berlin, which earlier had represented much of the best of what was happening in Western culture, that Hitler would perpetrate the greatest evil of the 20th century with his attempts to exterminate Jews, gypsies, and others who did not conform to his image of the "Ubermensch," or perfect Aryan. The attempt to perpetrate such evil, combined with his attempts to annex surrounding countries, precipitated World War II, a war which took an estimated 42,000,000 lives (military and civilian), in addition to the 6,000,000 Jewish people killed in the Holocaust. Furthermore, there was the displacement of millions of people and untold property damage. The European phase of World War II ended only with the

unconditional surrender of Germany and the near complete destruction of Berlin. The city suffered a further blow to its integrity, when the Soviet-ruled eastern part was severed from the allied sector that was ruled by the United States, Britain and France in 1961—a severance made possible by the almost overnight construction of the Berlin Wall.

Today, Berlin is experiencing what its residents call a second "Grundezeit" (time of foundation). East and West are again united in one city; the U-Bahn and the S-Bahn train systems interconnect the city so well that a naïve newcomer can hardly tell whether s/he is in an area that was once East or once West. Other than for the remembrance of historical sites, such as Checkpoint Charlie, most sections of the Berlin wall that once divided Berlin have been removed. Everywhere in the city the rebuilding construction activity is enormous. Cranes dot the skyline wherever one looks. The push to unity of the two Berlins has become even greater since the reunification treaty of 1990 provided for the capital city of Germany to be moved from Bonn to Berlin.

Using Stechow's 1970 book on Bruegel's art as my reference, I had expected to find Bruegel's *The Netherlandish Proverbs*, as well as his painting *Two Chained Monkeys*, at the Staatliche (Metropolitan) Museum, located on what is called Museum Island, a small piece of land on the Spree River, to which one walks over a short footbridge. The island is home to many museums containing artistic treasures from around the world. Perhaps the most famous is the Pergamon Museum, which houses one of Berlin's most highly regarded treasures, the Pergamon Altar (180-159 B.C.E.) from western Turkey, as well as the magnificent reconstructed gates of the ancient city of Babylon. But when I went there, the two Bruegel paintings were nowhere to be found on Museum Island.

Much to my surprise, they had been moved! Their new place of display was the Gemaldegalerie (Painting Gallery) near the New National Gallery, which is

part of the Kulturforum (Cultural Forum) at Kemperplatz. The forum is a complex of buildings located quite some distance from Museum Island (one needs to go by U-Bahn), on what had decades earlier been "no-man's land"—a strip of about 100 yards that surrounded the wall formerly separating East and West Berlin. Designed by Ludwig Mies van der Rohe, the Gemaldegalerie is a key part of the Cultural Forum. Housing paintings of all historical eras, the building itself is of modern design, built partly underground thereby making it appear much at one with its environment.

The Gemaldegalerie in the Cultural Forum provides a wonderful setting for *The Netherlandish Proverbs*. Here we have Bruegel's most unique painting, which recreates the essence of Flemish culture, on display in a building that embodies the emerging spirit of a Germany that is reunifying politically and culturally. Though separated by centuries, the reality portrayed in *The Netherlandish Proverbs* and the reunification of present-day Germany both represent formidable attempts to create cultural integration and wholeness.

My thoughts on the aesthetics of *The Netherlandish Proverbs* were brought home when I finally came face-to-face with the painting. It was late in the day because of the earlier misunderstanding about the painting's location. There were very few people in the Gemaldegalerie at that hour but, as I had often seen with other Bruegel paintings, there was a small crowd around it. Among the viewers two stood out. They were well-dressed, middle-aged Japanese ladies who spent what must have been the better part of 15 minutes rigorously examining one proverb after the other. Although they spoke no English, I could not help but notice the excitement in their faces as they too saw Bruegel's power to paint "that which cannot be painted," in this case the inner essence of the concept of culture. I am not sure whether they fully grasped the extent to which Bruegel had so brilliantly captured the essence of the five diverse societies that comprised 16th century

Europe, but their rapt attention to *The Netherlandish Proverbs* made it clear to me that the meanings conveyed in Bruegel's masterpiece readily transcended both the time and place where it was painted. *The Netherlandish Proverbs* is no simple, quaint genre piece that informs us of life in the lowlands of Europe in the 16th century. Rather, its complexity and its rich detail allow us to see the successes and failures, the struggles and follies of everyday life as people experience it. Indeed, the more you examine the painting, the more you realize the extent to which this marvelous work of art shows an extraordinary grasp of the soul of a culture, indeed, the essence of our social life.

Chapter 6
New York City, Today

Many people I have met who know of Pieter Bruegel's art have one particular painting to which they relate much more than the others. Perhaps they have seen it in a museum. More often they have encountered it in a book or in an art class. No matter how, it managed to so capture their interest that the imagery remained with them for years. An artist I know regards *Return of the Hunters* as one of the most perfect paintings he has ever seen. Several friends respond to the group conviviality of the genre paintings, especially *The Peasants' Wedding*. Three Bruegel paintings have inspired entire books of their own. Edward Snow, a Professor of English, spent 18 years of "close reading" in order to write his book about the kaleidoscopic world created by Bruegel in *Children's Games*. Michael Francis Gibson, editor of UNESCO's *World Heritage Review*, found in Bruegel's *The Way to Calvary* a compendium of religious imagery that not only included several varieties of Christian thought but also paganism and agnosticism. In the previous chapter we saw how Mark Meadow found in *The Netherlandish Proverbs* a new and innovative approach to understanding the essence of Flemish culture of the 1500's.

My enthusiasm for Bruegel's art has led me to conclude that virtually every one of his paintings is unique and full of meaning, both to his times and ours. Nevertheless, from the time I first saw it in Vienna, there is one painting that stands out over and above all the others, namely, *The Tower of Babel*. (See Plate 13.) Its imagery is enormously compelling. Indeed, the more I look at it and think about it, the more I realize that, in this painting, Bruegel has captured the essence, one might say the soul, of the Old Testament myth so powerfully, that it provides a way in which we can understand some of the basic social concerns that confront us today. For the past several years I have kept a print of the painting on the wall above the desk in my study, so that I can see it in different ways at different times. Perhaps this is why my reflections on the painting have come to be closely connected with thoughts about New York City, where I now live.

The Myth of the Tower of Babel

The myth of the Tower of Babel is at the soul of western culture. It is an Old Testament myth that has become an important part of the three great religions: Judaism, Christianity and Islam. The story of the myth is told in *Genesis, Chapter 11, verses 1-9*. By the time they built what is known as the Tower of Babel, the people of God had survived expulsion from the Garden of Eden (for sampling the fruit of the tree of good and evil) and destruction of flood (because God had found the earth to be corrupt and filled with violence). Only Noah, his family, and one male and female of every known species had survived. They all spoke one language and used the same words. According to the Biblical account, after the flood they wandered about in the East, came to a plain in Babylon and settled there.

The Biblical story goes on to say that, upon settling down, the people of God began to build—making bricks, baking them hard, and using tar to hold them

together. But, as reported in verses 4 through 9, there was a major problem with the nature of their enterprise:

> Then they said, "Come, let us build ourselves a city, and a tower with its top in the heavens, and let us make a name for ourselves, lest we be scattered abroad upon the face of the whole earth." And the Lord came down to see the city and the tower, which the sons of men had built. And the Lord said, "Behold they are one people, and they have all one language; and this is only the beginning of what they will do; and nothing that they propose to do will now be impossible for them. Come, let us go down, and there confuse their language, that they may not understand one another's speech." So the Lord scattered them abroad from there over the face of all the earth, and they left off building the city.

In other words, the story is one in which God punished the very creatures he had created. To be sure, the punishment was different from the expulsion from the Garden of Eden. Nor was it as final as the natural destruction of a flood from which only Noah and his entourage were spared. Rather, it was a punishment that went to the core of the social nature of humans, in that it consisted of the mixing up of languages and scattering of peoples. Moreover, it was rendered because humans attempted to create an overly ambitious structure (a tower that would reach to the sky) for the wrong reason (making a name for themselves, i.e., pride).

The myth of the Tower of Babel penetrated deeply into the thinking of Western culture. Early on, Hebrew writers such as Josephus concluded that the builder of the tower was Nimrod, the grandson of Noah's middle son, Ham. Neither a democratic leader nor a benevolent dictator, Nimrod came to be portrayed as a usurper of divine prerogatives, who conscripted people (although the Biblical story implies they were willing conscripts) to build a tower "against the Lord,"

one which symbolized his impious pride. In a Christian interpretation advanced in the *City of God*, Augustine saw the tower as part of man's arrogant activities that brought about divine retribution. Also early on, the myth's moral of confusion became incorporated as a word into many major languages. The Hebrew word "balal" means to mix or confuse. The word also doubles as a pun on the Akkadian word "babel." Babel, in turn, can be twisted to mean "gate of the god" or even "Babylon." In English we use the word "babble" to indicate meaninglessness or incoherence. Related words can be found in languages as diverse as Greek, Latin, Sanskrit, and Norwegian.

The myth of the Tower of Babel is especially relevant to the manner in which civilization developed in the Western world. From ancient times, Europe and the Middle East (as compared to China and Japan) were polyglots of unrelated societies, in which many languages were spoken. Thus, driven by social need, the role of interpreter appeared early on: in *Genesis, chapter 42, verse 23*, we read that Joseph, at the time an Egyptian official, spoke to his brothers through an interpreter, and they did not know that he understood them. The Roman author Pliny reports that the Romans needed 130 different interpreters simply to deal with the various peoples of the Caucasus. Even the famous Cleopatra was known not only for her beauty but also for her facility with languages. The dispersion of peoples has, from the outset, been a key part of the Western experience; in fact, the countries around the Mediterranean have long had populations of diverse ethnicity, a fair number of which were nomadic or semi-nomadic. Diversity of language and ethnicity still typify our 21st century world, in which many countries have significant groups of peoples who are not native born living in their lands.

There is a major division in the civilized world concerning how language differences are to be accommodated. For Muslims, the Qur'an, written as it was in Arabic, was regarded as the revealed word of God, and its translation expressly

forbidden. For Christians, it was quite the opposite. Educated Christians were expected to know Greek and Roman and, if they wanted to read the Bible, Hebrew and Aramaic. The difference between the Muslim and Christian approaches to language differences made it necessary to employ "dragomans," who served as translators of diplomatic and commercial documents, so that peoples in the European countries of the West could communicate with those in Turkey and the Middle East.

Language diversity and the need for translation between languages became increasingly complex about a generation before Pieter Bruegel's birth. The invention of movable type in 1436, by the German printer, Johann Gutenberg, had made it possible to print books, not only in the "universal" Latin of the day but also in vernacular tongues. After he nailed the 95 theses to the church door at Wittenberg in 1517, thereby challenging the authority of the one Holy Roman Church, Martin Luther translated the Bible into German. Eventually the Bible would become the all time best-selling book, and be translated into every major language around the world. There were other developments for languages during this period. In 1492, in Spain, the first grammar of a colloquial language, Castilian, was published. In that same year significant numbers of Jews and Muslims were expelled from Spain. Some learned Turkish. Some became the "dragomans" who, for hundreds of years, "translated" the languages of the East (especially Arabic and Turkish) into those of the West (especially Latin, Italian, French and English).

Bruegel's Painting of the Tower of Babel

Though the Tower of Babel story is well known, there is much question about whether such a tower ever existed. We do know that the ancient Babylonians thought of their gods as living in the sky, and attempted to build towers so that

they could get closer to them. Neboplasser (ruler from 625-605 B.C.), father of the famed Nebuchadnezzar, reportedly erected a structure during his reign that came to be regarded as the Tower of Babel. Herodotus, the great Greek historian, referred to it when he wrote about his travels sometime around 460 B.C. Similarly, Galen, the Greek physician who lived between 130 and 200 A.D., also referred to it when he traveled throughout the Mediterranean world centuries later. But it would remain until the late 19th century before archaeologists would unearth what they thought to be the base of the famous tower, in a small town in Iraq, not far from the modern city of Baghdad.

Vague though the knowledge about the actual Tower of Babel may have been, artists in the Western world began to depict an imagined tower as early as the 6th century A.D. In the 16th century, the tower became a favorite subject, especially for painters of the lowland countries. We know this because there are today more than 100 known artistic renderings of the tower, which date from the period of 1560 to 1610. The tower was, one might say, Pieter Bruegel's favorite subject, for he painted it no fewer than three times; his very famous *The Tower of Babel* that hangs today in Vienna (see Plate 13), a somewhat lesser known work of the same title that hangs in Rotterdam (see Plate 37) and a third which was lost. The two that hang in museums today are dated within five years of each other (1563 and 1568)

The intense interest in the Tower of Babel among artists of the 16th century lowlands reflects, in part, their desire to portray Old Testament themes. Images referencing the Garden of Eden were to be found in paintings such as Hieronymous Bosch's *Garden of Earthly Delights*, and its secularized version in Bruegel's own *The Land of the Cockaigne* (see previous chapter). In Germany Albrecht Durer had used two idealized Greek gods, Apollo and Venus, to portray Adam and Eve in his painting of the same name. But modern research has suggested that the intense

interest in the Tower of Babel went well beyond mere portrayal of a Biblical myth. In her in-depth, doctoral study of *The Tower of Babel*, Sara Weiner found that the subject matter of the painting was a thinly veiled allusion to the great religious and political issues of Bruegel's day, namely, the hegemony of the Roman Catholic Church and the tyranny of the Spanish monarchy. From this perspective, (1) Babel was the favorite metaphor of Protestant reformers to signify the papacy, (2) The Tower of Babel was a well-known symbol of the Roman Catholic Church, and (3) Nimrod was known as a cruel and tyrannical monarch.

Whether it was from a desire to depict, in complete detail, the imagery of the Tower of Babel story, the intent to critique the powers of his day, or both, Bruegel's use of realism in *The Tower of Babel* in Vienna was truly extraordinary. It is no wonder that this painting of the tower would early on set the standard by which all the others would be judged. Shown in Plate 13, *The Tower of Babel* contains each of the major themes of the genesis myth: (1) a king or emperor in the lower left corner, thought to be Nimrod, creator of the incomplete, imperfect structure that represents the punishment for his sin of pride, in endeavoring to build a tower to the heavens, (2) the people bowing to him, who have been duped by his false dream, (3) the small hut-like houses for groups of tradesmen (on the lower levels of the tower), who are unable to understand each other because of the argot of their diverse trades, (4) the ships in the harbor ready to carry out the movement of the peoples to other places, and (5) the urban sprawl on both sides, and presumably to the rear of the tower, resembling the Antwerp of Bruegel's day, with a building boom created by the need to house the workers required to build the tower.

Nevertheless, the most distinctive feature of the painting is the tower itself. Appearing to be crumbling and sinking to the left rear, it bears a strong, uncanny resemblance to the Coliseum of Rome. Bruegel visited Rome sometime during his Italian "tour" of 1552-1554, and presumably went to the Coliseum. At that time,

he would have known that many artists went to Rome (and other places in Italy) to depict the ruins of the ancient world, so that ancient civilizations could be seen from new perspectives.

But Bruegel used realistic depiction and painted the Coliseum (Tower of Babel) not as a ruin but rather as a symbol. We do not know exactly why he did this, but in a recent fictionalized account, *As Above, So Below*, Rudy Rucker suggests that the young Bruegel got the inspiration for his painting upon hearing that Michelangelo, an old man at that time, was designing a dome for St. Peter's Church. Bruegel had originally planned to use the St. Peter's dome as the symbol for his *The Tower of Babel*, but changed his mind upon hearing that the famed Michelangelo was involved in construction of the St. Peter's dome. However, upon seeing the Coliseum, he realized that it would be, for him, a far better symbol of what he wanted to portray. Looking at the painting and bearing the Coliseum in mind, one can indeed visualize, like Rucker, Bruegel spending a day at the site "…exploring the ancient stadium, sketching its arcades of arches, nosing around its subterranean halls, drawing it from below, then clambering up the fins of the inner buttresses and drawing it from above." Today, the Coliseum is rather different from what it was in Bruegel's time: cleaned up, reinforced, and reconstructed, although overrun by tourists and visitors. But, if you go there after having seen Bruegel's painting, *The Tower of Babel*, and look at the Coliseum from all its different sides, from a distance, from as far up as you are allowed to go, down to its very base, you can easily imagine you are seeing Bruegel's Tower of Babel.

In selecting the Coliseum to represent the Tower of Babel, Bruegel used a universal symbol of Western civilization. Centuries earlier, The Venerable Bede (672-735 A.D.) had put its significance in the following words (subsequently translated by the English poet, Lord Byron):

While stands the Coliseum, Rome shall stand

When falls the Coliseum, Rome shall fall

And when Rome falls—the world.

In short, the Coliseum is a structure that has for centuries embodied the soul of a city that still calls itself "eternal," and one that embodies much of the essence of Western civilization (to Bede, the entire world).

The universal symbol of the Coliseum is, indeed, its own virtual Tower of Babel. It was at the Coliseum where the clash of the "ancient" and "modern" civilizations of the day was made real, through public spectacles that pitted the values of the newly emergent Christian sects against those of the ancient Roman gods. It was at the Coliseum that one could witness the depravity of the game of one man battling another to the death, or a lone man confronting a beast. By the same token, one could also see these contests as extolling the heroism of a person facing death for deeply held beliefs that questioned the very basis of the established social order. Moreover, the Coliseum meant Rome, and it was in Rome that the Catholic Church based its authority, and from Rome that it exercised its power. Just as authority and power were used to uphold certain civilized values, they could also be used to acquire great wealth and power, with the masses of people kept ignorant of what was going on.

To appreciate Bruegel's use of the Coliseum as symbol for the Tower of Babel, as well as his detailed use of realistic depiction in *The Tower of Babel*, we can contrast it to the other *The Tower of Babel,* a painting dated only a year later, which hangs today in Rotterdam. (See Plate 37.) Gone is the human figure radiating power. Gone is the structure that hauntingly suggests the Coliseum. Gone is the urban scene that so resembles Antwerp. To be sure, there is a tower, but its details are much less distinct. Moreover, the Rotterdam painting is much smaller,

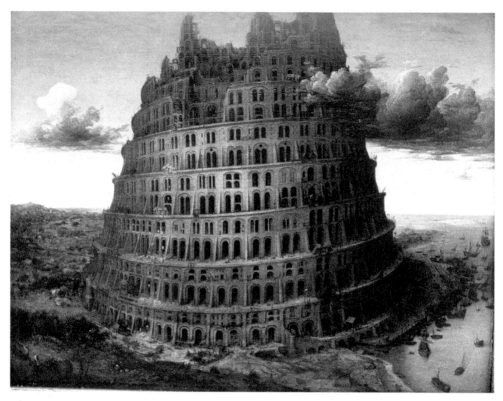

Plate 37: *The Tower of Babel* (Rotterdam), 1568
Oil on panel, 23 5/8 x 29 3/8 in
Museum Boymans van Beuningen
Rotterdam

at 23-5/8 by 29-3/8 inches (compared to 44-7/8 by 61 inches), and the colors are darker. The result is that the Tower of Babel story is told more through allegory than realism. Although most viewers are more captivated by the Vienna tower, with its realistic details, later painters typically copied the tower, and art historians have often taken the Rotterdam tower as their model. If the Rotterdam Tower of Babel stands as an artistic rendering of the well-known Old Testament myth, the Vienna tower is more a painting of the inner dynamic of the social order of western society.

Bruegel's *The Tower of Babel* and Today's World

If we look at ourselves through the lens of Bruegel's *The Tower of Babel*(in Vienna), we cannot miss seeing the confusion of language and the scattering of peoples that lie at the heart of the myth. Although languages around the world are disappearing at a considerable rate, more than 5,000 are still spoken today. Moreover, many have local dialects, which are so distinctive that they border on being languages in their own right. In our rapidly changing world order, there is a continual movement of peoples, especially from Africa, Asia and the Middle East to Europe, Australia, Canada, and the United States.

The multiplicity of languages is a special concern for many countries around the world. Perhaps the only exception is the People's Republic of China, which is unique for a country of its size. Although it has people of diverse linguistic groups, it employs but one official language, making Mandarin Chinese the most commonly spoken language in the world. By comparison, the European Union, with its 25 member countries and population of several hundred million, utilizes 12 languages to conduct its business. Obviously there is a constant need for translation. The somewhat smaller United States, with a population of 280,000,000 people, uses but one official language, although many individuals and organizations have long made efforts to change this policy to include two (or more) languages. If we go beyond the official languages of almost any country, to take into account the languages spoken by its populace, the number of diverse languages increases greatly. Because of widespread immigration in recent years, especially into the United States and many of the countries of the European Union, there are substantial numbers of people for whom the language spoken in the country in which they reside is not their mother tongue. By the same token, natives of countries with foreign immigrants are continually exposed to languages

other than their own. The net result is that, depending on the individual's facility with language, the everyday world of most people is characterized by hearing one or more foreign tongues spoken, i.e., by some degree of "babble." Should we say that the Tower of Babel is as much reality today as it is Old Testament myth?

How We Deal With Babble

If our world is, indeed, a Tower of Babel, it does not mean that we need to sink into the despair of muddle and confusion. We can develop ways of dealing with babble, that is, of penetrating through it. To get out of babble, we take various perspectives that allow us clarity on some aspects of social reality, even if it means that we ignore others. One way of exploring perspectives on the Tower of Babel is to look at three books, each of which has employed Bruegel's *The Tower of Babel* as the motif for its cover. Although it is said that you can't judge a book by its cover, we would argue that the imagery of *The Tower of Babel* has remained so potent, that three writers of current books have used Bruegel's masterpiece as their cover. The diversity of ideas covered in the three books tells much about how modern elaborations of the Old Testament myth remain compelling.

One of the three is Umberto Eco's *Serendipities*, which uses a Tower of Babel perspective to capture "...ideas, projects, beliefs that exist in a twilight zone between common sense and lunacy, truth and error..." Reading his essay, "The Force of Falsity," one cannot help but appreciate the fragility of the boundaries of truth and error (or right and wrong), when one reflects how Columbus, though wrong in thinking the earth smaller than it actually was, was right to pursue his error, and thereby find a new world. Conversely, the sages of Salamanca, thinking the earth larger than it was, and thereby incapable of circumnavigation to reach the orient, were right in their analysis, but wrong in thinking it mad for him to pursue the venture.

Eco carries the Tower of Babel perspective even further, when he asserts, in another essay in *Serendipities*, that creation of the world was, in fact, an act of speech. As he puts it, it was in giving things names that God gave them an ontological status. So it was that light became "day," darkness "night," and so forth. The use of words to create realities continues to this day. Politicians gain our votes by picturing a world, often in utopian terms, that is supposedly better than the one in which we presently live. Merchandisers promise all kinds of benefits if we buy the products they wish to sell. News reports and editorialists use words to articulate realities that go far beyond those we normally experience in our everyday lives. Preachers use languages of theology to understand the workings of a God no person has ever really seen. The enormous diversity in our use of language has led historians of natural language, such as John McWhorter, to argue that babble is power, in his book titled, *The Power of Babel*. After all, if there are 5,000 languages in the world, and if each one continues to adapt to life as it changes, there are an enormous number of ways each of us can give meaning to the reality that surrounds us. From this viewpoint, however imperfect and fallible it may be, the world needs "babble." The irony is that, in using words to get rid of confusion, we may gain some clarity and, at the same time, create more confusion.

In Jasper Ridley's book, *The Freemasons*, another book for which Bruegel's painting provides a cover, we find the Tower of Babel myth associated with the practical trade of construction. One might question why the secret society of Freemasons would have an interest in the Tower of Babel but, if one accepts Ridley's argument, the Freemasons, especially at the time of the founding of their society in the Middle Ages, consisted largely of masons who were builders. According to the beliefs of those who practiced Freemasonry, God himself was a mason and masons built the Tower of Babel, even as they communicated through

secret signs and spoke diverse languages. In this vein, some commentators on the Bruegel painting have thought that the huts on the fourth tier of the tower are those of tradesmen, and they are quite noticeable in the reproduction on Ridley's book cover. While there is no way to tell whether the tradesmen are masons, we do know that craftsmen of Bruegel's day were organized into guilds, each of which had its unique trade language or "argot," through which its members communicated with one another. Given the problems of communication between and among the many groups, each of which spoke its own language, is it any wonder that the building of the tower was far from perfect in its outcome?

Just as we can associate the Tower of Babel with serendipity, with the power of language and with construction of buildings, we can also see it as a metaphor for the growth in facility of communication that is a part of each individual's experience. This viewpoint is taken by Gerry T.M. Altman, who notes in his book, *The Ascent of Babel,* that each of us enters this world, figuratively, as an infant at the base of the tower, and promptly begins a long climb upward, so that, as adults, we come to stand at its summit. The tower is built upwards, each tier resting upon the ones built earlier. Altman poses the fascinating question of whether Bruegel, once having imagined it, could have painted the tower any other way than from the bottom up. Psycholinguistics is just at the beginning of understanding each stage of the process, one that begins in the womb, when we first distinguish phonemes, then moves on to our grasp of syllables, meanings of words, grammars of rules, and, finally, sentences, paragraphs, and larger units of meaning. Somehow each one of us eventually comes to construct some level of competence in conveying meaning, in both speech and writing. Once we have reached our level of competence, we can descend the metaphorical tower, go into the world, and realize our full humanity.

If we think of the Tower of Babel as a challenge to surmount, or as an uphill

battle that is, in effect, a process of growth, we can appreciate the genius of Bruegel's *The Tower of Babel* in a deeper way. As mentioned earlier, the uncanny resemblance between the Tower of Babel as depicted by Bruegel and the Coliseum of Rome cannot be missed. Nevertheless, there is one pronounced difference. Bruegel's tower has between seven and nine tiers (depending on how one counts them) whereas the real Coliseum, as it stands in ruins today, has only two or three. Although we are unaware of his reasons, Bruegel's portrayal of the Coliseum with more tiers than it actually has serves to transform the symbol of the Coliseum, with all of its meaning, into the Old Testament metaphor/myth of the Tower of Babel. To the extent that complex levels of meaning characterize social realities, Bruegel has once again given us an image through which we can appreciate the complexity of our social world.

New York City—9/11/01

Bruegel lived a century before New York City was even identified as a place on the maps of Europeans. Curiously, however, the imagery portrayed in *The Tower of Babel* also resonates in certain ways with the city's soul.

Never just another city, New York has long had its own distinctive mystique. It is full of paradoxes and contradictions. First chartered as a trading post in 1609 by the Dutch, who had little appreciation of its potential, it was ceded, not without some subterfuge, to the English in 1664 who treated it as a colony. After American independence, and throughout the early 1800's, it was comparable to and competitive with Boston and Philadelphia. But by 1900 it had far surpassed its competitors, becoming the country's largest and wealthiest city. For the first half of the 20th century, New York enjoyed an unchallenged supremacy. Its main avenue, Broadway, became known as the "Great White Way." Its department store windows showcased goods from around the world. At the same time, New York

provided the capital, both monetary and intellectual, that sparked the growth of America, as it made the transition from a localized agricultural land to a national industrial country. Moreover, it was the only major city of the Western world that did not suffer widespread destruction during World War II.

If the ancient Tower of Babel was the place from which the peoples of the world were dispersed, New York City of the 20th century was the place to which displaced people came. The decades between 1890 and 1920 were ones in which millions of immigrants, mostly of European origin, entered the United States. Although some went on to other cities, many remained in New York. They made New York a city of immigrants, a characteristic that it continues to have, even if the more recent immigrants come from virtually every country in the world. The city's immigrant character is ubiquitous. All you have to do is overhear the conversations of people on its streets and in its stores, ask your cab driver what country she or he comes from, or talk to any of its teachers of English, including English as a Second Language, who have to deal with mispronunciations, misspellings, and awkward grammatical constructions, as they attempt to teach the "newcomers."

New York's skyscrapers gave expression to a very different aspect of the Tower of Babel myth. As mentioned earlier, the Genesis story told how the people of God sought to build a city with a tower that reaches the sky, so that they would make a name for themselves. For New Yorkers, the motivation may have been secular rather than religious, but as an island city built upon bedrock, it became the world's first skyscraper city. In fact, by 1960 it had the world's three largest buildings, and three quarters of the world's skyscrapers were located there. Today its Empire State and Chrysler buildings continue to provide a powerfully distinctive design for its picturesque skyline. The twin towers of its World Trade Center stood for a number of years as the tallest building in the world complete with observation decks from which to obtain spectacular views of the rest of the city's skyline.

Adding to the unique mystique of New York is the rapid pace with which immigrants came and skyscrapers (as well as many other buildings) were erected. The chaos and confusion that could have been engendered were turned, instead, into sources of creativity. Early on, in 1854, Broadway was labeled by the writers of *Putnam's Monthly* as "a Babel scene of confusion…altogether the most showy, the most crowded, and the richest thoroughfare in America…collected into one promiscuous channel of activity and dissipation." Rather similar thoughts about the city were echoed a century later by the writer John Steinbeck, who lived there during much of his adult life. In 1953 he put it this way, when he wrote in *New York Magazine:*

New York is an ugly city, a dirty city. Its climate is a scandal, its politics are used to frighten children, its traffic is madness, its competition is murderous. But there is one thing about it—once you have lived in New York and it has become your home, no place else is good enough.

Earlier, another writer, E.B. White, caught its creative confusion, when he described New York as a babble of contradictions, an aesthetic chaos of "elusive meaning." According to him, the city seemed to revel in contradictions:

At the feet of the tallest and plushiest offices lie the crummiest slums. The genteel mysteries housed in the Riverside Church are only a few blocks from the voodoo charms of Harlem. The merchant princes, riding to Wall Street in their limousines down the East River Drive, pass within a few hundred yards of gypsy kings, but the princes do not know they are passing kings, and the kings are not up yet anyway—they live a more leisurely life than the princes and get drunk more consistently.

However, not all the images of New York are creative or positive. In the decades of the 1960's, 70's and 80's the New York story turned bleak, as people moved to the suburbs, and opportunities diminished. Many of those left in its slums, especially the poor, became overwhelmed, even defeated by life in a society ridden with crime, drugs and violence. The immigrants who did continue to come to the city were generally much poorer than their predecessors. Construction of new buildings slowed; other cities built more and higher skyscrapers than did New York. The city actually lost population during the decades of the 1960's, 1970's and 1980's. The positive immigrant and skyscraper city images gave way to images of the city as dangerous. Indeed, it remained for the 1990's until New York began a turnaround and came to be seen as something less than the most dangerous place in the United States.

On September 11th, 2001, the image of New York became cast in still another light.

Who knew that there were people who saw the World Trade Center not as the epitome of global world trade but as the symbolic expression of a corrupt and evil international capitalism? Who knew that there was a group of people who would, seeing these skyscrapers as perverse forms of religious expression, give their lives to the cause of destroying them, so that they could achieve their own immortality? Who knew that they would use our own airplanes to accomplish the destruction, and then have it played out before our very eyes on television? Who realized, at the time, that the events of this one day (and our reaction to them) would so alter the course of world history, that many would come to see 9/11/01 as the true beginning of the 21st century?

The shock and magnitude of the destruction tested New Yorkers and, for that matter, all Americans, in a new way. Suddenly, everyone needed to make sense out of what seemed nothing but confusion. Why had the United States, New York

City, the World Trade Center, and the 3,000 people who happened to be in the building that day been selected as targets? What did it all mean?

The search for the words to put the events of 9/11 into perspective began literally the following day. In the immediate aftermath, it became apparent that the so-called diversity, seen in the differences among New Yorkers, was in fact a strength that united them. The outpouring of support for the victims, and for those who gave their lives in rescue of them, astonished the most cynical of observers. As the days went by, the power of babel became evident. Preachers reached new spiritual heights as they sought ways to comfort victims and to understand the horrific events. Columnists began to broaden their perspective on events, by setting them in larger global and historical contexts. Politicians used the events as cues for major changes in foreign and domestic policy. And New York City began a long process of building the appropriate structures to replace those that had been destroyed, a process that will continue for many years.

Given everything else we have observed about Bruegel, is it surprising that a look at his art even provided a perspective on the events of 9/11? By coincidence, in September 2001, there was an exhibition of Bruegel's prints at the Metropolitan Museum of Art. (In addition to his paintings, Bruegel also produced a significant number of drawings and prints.) Although the museum understandably became very concerned with security, many people, including my wife and myself, flocked to the exhibition in the weeks after 9/11. The reasons that so many people would want to see Bruegel prints in the aftermath of 9/11 were succinctly put by Martin Kimmelman, art critic of the *New York Times*, who wrote on September 20th, in a review of the exhibition:

> Bruegel lived in rough and crazy times, but beauty, his work reminds us, makes comforting order out of almost everything it comes into contact with. (Regardless

of what he was painting)…he delivered the same lapidary message. The world is anarchic and cruel and can drive all of us into despair sometimes. But good art is a realm unto itself, with its own rules and rationale, and thankfully we can escape into it from time to time when we need to regain our senses.

Obviously Bruegel did not paint *The Tower of Babel* with 9/11 in mind. But Bruegel's masterpiece was completed at the time of a significant historical turning point, and 9/11 was arguably another turning point. As we have seen repeatedly in looking at Bruegel paintings hanging today in cities throughout Europe and the United States, Bruegel saw a world that was at once tragic and comic. It was a world in which natural beauty coexisted with human depravity. It was also a world marked by confusion of languages, clashes of cultures, and conflicting myths of social order, all confounded by human pride. In short, a world in many ways that was rather like our own.

Perhaps the key point is that Bruegel painted this world in such a way that he allows us to understand it for what it is, indeed, to see into its soul. My own interest in Bruegel's art had begun years earlier in Madrid, where I experienced how he captured the essence of the social change we call "urbanization," and the ongoing struggle of life versus death. It continued in Vienna, where I saw how he caught the essence of seasonality in our social life, the out-of-the-normal events of crucifixion, suicide, conversion, and struggle between carnival and lent and play, as well as the everyday life of his times, with its round of dance, banquets, and weddings. It continued further as I traveled through Brussels, Rome, Naples, and a host of other cities, where I saw paintings that embraced so much of the society of his day, whether it was the seigniorial society, the theological society, the territorial state, or the emerging towns and cities.

That said, Bruegel's painting *The Tower of Babel* stands, I think, in a category

of its own in that it provides a lens through which to understand some of the moral complexity that is at the heart of our civilization. To look at it is to see the confusion and miscommunication that plague our efforts to understand one another, and to attain a viable global order. To look at it is to realize the scattering of peoples that continues to this day. We can also see the resulting housing boom that seems very much with us. Finally, *The Tower of Babel* allows us to reflect upon the pride of humans, which often serves to make things worse rather than better. Nevertheless, Bruegel's tower is not depicted as one in ruins but, rather, as one that is imperfect. So it is that this wonderful painting allows us a glimpse into the soul of Western culture. At the same time that it depicts an ancient Biblical past, it depicts an ancient secular Rome, a sacred Rome of the Middle Ages and, remarkably, hints at key aspects of world order today. Perhaps that is why it seems to have a certain Bruegelian "something more" that points us toward the future much as it captures the essence of our past.

Page Notes

Note: Numbers in brackets refer to bibliographic entries of the same number.

Chapter 1: Madrid, 1972

p. 1 Think like Leonardo: Gelb , [19].

1 Proust and personal growth: Botton, [8].

1 Mine Shakespeare: Bloom, [5].

2 Connoiseur of art: Hoving [24], p. 2.

3 Worldscape: Joseph Leo Koerner, "Serious Mischief," in *The New Republic,* February 1, 1999, p. 28.

8 Famines and plagues: Cantor, [12] and Tuchman, [42].

9 Returning soldier: Museum Mayer van de Bergh, "Pieter Bruegel, The Younger, *The Triumph of Death,* (Antwerp: Pamphlet of the Museum, 1993).

10 Bruegel and play: Snow, [40].

10 Bruegel and Calvary: Gibson, [20].

11 Bruegel as painter of things that cannot be painted: Gibson, [20], p.12.

11 Art expresses nature: de Balzac, [3], pp. 13-14.

Chapter 2: Vienna, 1997

14 Genius painter: Janson, [27], p. 520.

15 Habsburgs: see Wheatcroft, [45].

15 Austria: see Rickett, [36].

17 Bruegel paintings at Kunsthistorisches Museum: Seipel, [39].

21 Missing seasonal: Frayn, [17].

21 *Drunkard pushed into the Pig Sty* sold at auction in 2002, fetching 3.305,600 pounds (ca. $5,000,000): Catalogue, "Important Old Master Pictures," (London: Christies, 2002), pp. 68-73.

22 Eco-Bruegel: Hagen, [23], pp. 55-57.

22 Seasonal paintings: see Stechow, [41].

24 Exquisite beauty: Huxley, [26], pp. 139-159, passim.

26 Life as the painter knew it: Priestly, [35], pp. 104-105.

26 Book cover ice age: Fagan, [16]

30 Swallow mountains: van Mander, [29], p. 153.

32 Mannerism: Janson, [27], p. 463.

34 Kernel of reality: Barzun, [4], p. 196.

35 Painting as way of thinking: Snow, [40], p. 3.

35 Play: Huizinga, [25].

40 Observing peasants: van Mander, [29], p. 154.

40-41 Natural historian: Huxley, [26], pp. 153-154.

42 Hierarchy of superiority in art: Acton, [1], p. 129.

43 Bird nester puzzle: Vohringer, [43], p. 133.

Chapter 3: Antwerp and Brussels, 1998

48 Bruegel's life: Gibson, [21].

49 Bruegel's places and times: Braudel [9], esp. p. 152 and [11].

49 Number of painters in Antwerp, Hagen, [23], p. 15.

49 Bruegel's print works: Orenstein, [33].

55 Bosch: World of dreams: Bosing, [7], p. 7.

59 Nature as felicitous: van Mander, [29], p. 153.

59f History of Brussels: Wheatcroft, [45], Ch. 4.

61 Abdication of Charles V: Braudel, [11], pp. 931-937.

62-63 Love of truth: van Mander, [29], p. 154.

68 Practice in manner of Bosch: van Mander [29], p. 153.

69-70 Quotation of Ortels: Gibson, [20], p. 198.

Chapter 4: Rome and Naples, 2001

74-75 Travel: Montaigne, [32], See esp. re: vanity and diversion.

75-78 Travel of Bruegel: Gibson, [21], Ch. 2.

76 Antiquity: Fromentin, [18], p. 10.

77 Pictures from life, Italian journey: van Mander, [29], p. 153.

82 Naple's sense of doom: Fodor's 2001, "Italy" (New York: Travel Publications, 2001), esp. p. 517.

83-84 Naples in middle ages: Braudel, [9], esp. p. 480. See also Davies, [13], p.729.

84 Farnese Collection: see Nicola Sponosa, "The Farnese Gallery: The European Schools (Italy: Ministero per I Beni e le Attivita Culkturali, 2000).

Chapter 5: San Diego to Prague, 2001-2004

92 Complexity of medieval society: Braudel, [10], Ch. 5.

94-95 Emergence of Europe: Davies, [13], p. 496.

95 Changed perception of World: van Doren, [14], Ch. 7.

99 Bruegel's religious orientation: Stechow, [41], p.102.

112 Myth of cockaigne: Pleij, [34].

118 Netherlandish Proverbs: Meadow, [30], esp. pp. 153-157.

118-119 Topsy-turvy world: Stechow, [41], p. 56.

120 Ortels: see Boorstein, [6], pp. 275-278.

Chapter 6: New York City, Today

126 Re: meaning of tower: Gideon Goren, Private Correspondence (2003).

127 Tower of Babel: *The Holy Bible*, Revised Standard Version.

128 Tower of Babel myth relevance: Lewis, [28], Chapter 2.

129f History and archaeology of the Tower of Babel: Andre Parrot, "The Tower of Babel; Studies in Biblical Archaeology, No.2," trans. by Edwin Hudson, (New York: Philosophical Library, 1958).

131 Artistic renderings of the tower: Weiner, [44].

132 Fictionalized account: Rucker, [38], esp. p. 41.

136 Twilight zone ideas: Eco, [15].

137 Babel as power: McWhorter, [31].

137 Babel as construction: Ridley, [37].

138 Babel as growth in facility of communication, Altmann, [2].

141 New York as ugly, dirty city: John Steinbeck, New York Magazine, 1953.

141 New York as plushiest offices in crummiest slums: White, [46], pp. 29-30.

143-144 Review Bruegel exhibition: Martin Kimmelman, New York Times, September 28, 2001.

Bibliography

[1] Mary Acton, *Learning to Look at Paintings.* London: Routledge, 1997.

[2] Gerry T. Altmann, *The Ascent of Babel: An Exploration of Language, Mind, and Understanding.* New York: Oxford University Press, 1997.

[3] Honore de Balzac, *The Unknown Masterpiece.* (Trans.by Richard Howard, Intro. by Arthur Danto) New York: New York Review Books, 2001.

[4] Jacques Barzun, *From Dawn to Decadence; 1500 to the Present: 500 Years of Western Cultural Life.* New York: Harper Collins, 2000.

[5] Harold Bloom, *Shakespeare: The Invention of the Human.* New York: Riverhead Books, 1998.

[6] Daniel J. Boorstein, *The Discoverers; A History of Man's Search to Know his World and Himself.* New York: Vintage Books, 1983.

[7] Walter Bosing, *Hieronymous Bosch; c 1450-1516, Between Heaven and Hell.* Koln: Benedikt Taschen Verlag GambH, 2000.

[8] Alain de Botton, *How Proust Can Change Your Life.* New York: Vintage Books, 1997.

[9] Fernand Braudel, *The Perspective of the World; Civilization and*

Capitalism, 15th – 18th Century. New York: William Collins Sons and Co. and Harper and Row, 1984.

[10] ———*The Wheels of Commerce; Civilization and Capitalism, 15th-18th Century.* New York: Harper and Row Publishers, 1982.

[11] ———*The Mediterranean World in the Age of Philip II.* Berkeley: University of California Press, 1973.

[12] Norman Cantor, *In the Wake of the Plague; The Black Death and the World It Made.* New York: Simon and Schuster, 2001.

[13] Norman Davies, *Europe; A History.* New York: Harper Collins Publishers, 1998.

[14] Charles van Doren, *A History of Knowledge; Past, Present, and Future.* New York: Ballantine Books, 1991.

[15] Umberto Eco, *Serendipities; Language and Lunacy; A Brilliant Illumination of Intellectual History.* Trans. By William Weaver. San Diego: A Harvest Book; Harcourt Brace & Company, 1998.

[16] Brian Fagan, *The Little Ice Age, How Climate Made History. 1300-1850.* New York: Basic Books, 2000.

[17] Michael Frayn, *Headlong.* New York: Picador, 1999.

[18] Eugene Fromentin, *The Old Masters of Belgium and Holland.* Trans. by Mary C. Robbins. Boston: James R. Osgood and Company, 1882.

[19] Michael J. Gelb, *How to Think Like Leonardo da Vinci; Seven Steps to Genius Every Day.* New York: Dell Publishing, 1998.

[20] Michael Francis Gibson, *The Mill and the Cross; Pieter Bruegel's 'Way to Calvary.'* Lausanne, CH: Acatos, 2000.

[21] Walter S. Gibson, *Bruegel.* New York: Thames and Hudson, 1977.

[22] ———*Pieter Bruegel and the Art of Laughter.* Berkeley and LosAngeles: University of California Press, 2006.

[23]　Rose-Marie and Rainer Hagen, *Pieter Bruegel, The Elder, c 1525-1569; Peasants, Fools and Demons.* Koln: Taschen, 2000.

[24]　Thomas Hoving, *Art for Dummies.* Foster City, CA: IDG Books Worldwide, 1999.

[25]　Johan Huizinga, *Homo Ludens; A Stury of the Play Element in Culture.* USA: Roy Publishers, 1950.

[26]　Aldous Huxley, *"Brueghel"* in his *Along the Road; Notes and Essay of a Tourist.* New York: George H. Doran Company, 1925, pp. 139-159.

[27]　H.W. and Anthony F. Janson, *History of Art*, Sixth Edition. New York: Harry N. Abrams, Inc., 2001.

[28]　Bernard Lewis, *From Babel to Dragomans; Interpreting the Middle East.* Oxford: Oxford University Press, Inc., 2004.

[29]　Carl van Mander, *Dutch and Flemish Painters; Translation from the Schilderboeck. New Yor*k: McFarlane, Warde, McFarland, 1936.

[30]　Mark A. Meadow, *Pieter Bruegel The Elder's Netherlandish Proverbs; and the Practice of Rhetoric.* Zwolle: Wanders Publishers, 2002.

[31]　John McWhorter, *The Power of Babel; A Natural History of Language.* New York: Henry Holt and Company, 2003.

[32]　Michel de Montaigne, *The Complete Works: Essays, Travel Journal, Letters.* New York: Alfred A. Knopf, 1976.

[33]　Nadine M. Orenstein, Ed., *Pieter Bruegel The Elder; Drawings and Prints.* New York: The Metropolitan Museum of Art/New Haven and London: Yale University Press, 2001.

[34]　Herman Pleij, *Dreaming of Cockaigne; Medievel Fantasies of the Perfect Life.* Trans. by Dianne Webb. New York: Columbia University Press, 2001.

[35]　J.B. Priestly, *Rain Upon Godshill; A Further Chapter of Autobiography.*

New York and London: Harper and Brothers Publishers, 1939.

[36] Richard Rickett, *A Brief Survey of Austrian History.* Vienna: Georg Prachner Verlag, 1966.

[37] Jasper Ridley, *The Freemasons; A History of the World's Most Powerful Secret Society.* New York: Arcade Publishing, 2001.

[38] Rudy Rucker, *As Above, So Below; A Novel of Peter Bruegel* (New York: New York: A Tom Doherty Associates, Book, 2002.

[39] Wilfried Seipel, Ed., *Pieter Bruegel The Elder; at the Kunsthistorisches Museum in Vienna.* Milan: Skira, 1998.

[40] Edward Snow, *Inside Bruegel: The Play of Images in Children's Games.* New York: North Point Press, 1997.

[41] Wolfgang Stechow, *Pieter Bruegel The Elder.* New York: Harry N. Abrams, 1990.

[42] Barbara Tuchman, *A Distant Mirror; The Calamitous 14th Century.* New York: Ballantine Books, 1978.

[43] Christian Vohringer, *Pieter Bruegel; 1525/1530-1569.* Cologne: Konemann Verlagsgesellschaft mbH, 1999.

[44] Sarah Elliston Weiner, *The Tower of Babel in Netherlandish Painting.* Doctoral Dissertation: Columbia University, 1985.

[45] Andrew Wheatcroft, *The Habsburgs; Embodying Empire.* London: Penguin Books, 1995.

[46] E. B. White, *Here is New York.* With a New Introduction by Roger Angell. New York: The Little Bookroom, 1949, 1976.

Appendix 1

GAMES DEPICTED IN *CHILDREN'S GAMES* SHOWN BY NUMBER, LOCATION IN PAINTING, NAME OF TRADITIONAL GAME, TYPE OF ACTION DEPICTED AND COMPARABLE MODERN GAME

Notes on Table:

Column 1: Numbering of games (up to 75) follows Vohringer, [43], p. 52.

Column 2: Location of game refers to its place in the painting (TL = Top Left, BL = Bottom Left, TC = Top Center, BC = Bottom Center, TR = Top Right, BR = Bottom Right)

Column 3: Name of Traditional Game: In listing the names of the games as they were known, I have followed Vohringer, [43], p. 52 and Snow, [40], passim.

Columns 4 and 5: Type of Action Depicted and Comparable Modern Game or Play Activity are my wordings. "NCMG" stands for "no comparable modern game.

No.	Lo.	Name of Traditional Game	Type of Action Depicted	Comparable Modern Game or Play Activity
1	BL	Fivestones or Knucklebones	Dicing (as played by ancient Greeks and Romans)	Craps and other dice games
2	BL	Ragdolls	Pretending	Playing with dolls
3	BL	Children's church, improvised altar	Pretending (religious ritual)	NCMG
4	TL	Masks, fancy dress	Pretending	Wearing masks, dress- up
5	TL	Rocking	Bodily movement	Rocking horse
6	BL	Drillmoot, spinning nut	Spinning, turning	Yo-yo
7	BL	Blowing bubbles	Blowing	Blowing Bubbles
8	BL	Rush hats	(No clear meaning)	NCMG
9	BL	Taming birds	Training	Teaching tricks to a pet
10	BL	Brick dog	(No clear meaning)	NCMG
11	BL	Top or gyroscope	Spinning, turning	Top
12	BL	Water Pistol	Shooting	Water pistol
13	BL	Bird and bird house	Caring	Keeping animals
14	BL	Single file, baptismal procession	Pretending (religious ritual)	NCMG
15	BC	Hobby horse	Rocking	Hobby horse
16	BC	Drum and horn	Making music	Drum and horn
17	BC	Stirring excrement	Turning, mixing	Making mud pies
18	BC	Rolling hoops	Spinning, turning	Hoola-hoop
19	BR	Balloon (from an inflatable pig's or cow's bladder)	Blowing, bouncing	Balloon (made of rubber or other synthetic)
20	BR	Playing shops	Pretending (go shopping)	Playing Store
21	BR	Horsey horsey (one group makes the horse, the other jumps on as riders)	Riding	Horseplay
22	BR	Planing	Two groups lifting a body (over a table)	NCMG
23	BR	Throwing knives	Throwing	Throwing knives
24	BR	Building a well	Digging, constructing	Digging holes

No.	Lo.	Name of Traditional Game	Type of Action Depicted	Comparable Modern Game or Play Activity
25	BR	Riding a barrel	Riding	Horseback riding
26	BC	Shouting into a barrel (echo)	Yelling (voice)	Yelling (hearing oneself)
27	BL	Hoodman blind	Seeing, perceiving as well as mocking	Blind man's bluff
28	BC	Odds and evens	Guessing	Twenty questions
29	BC	Tug-of-war (mounted)	Struggling and Cooperating	Tug-of-war
30	BC	Leapfrog	Jumping (over obstacles)	Leapfrog
31	BC	Running the gauntlet	Running (coping with obstacles)	Running the gauntlet; running the mill
32	BL	Gymnastics: headstand, forward roll, tie self in knot	Balancing, exercising, contorting	Gymnastics
33	TC	Sitting/riding a fence or railing	Balancing	Gymnastics using a fence or railing
34	TC	Wedding procession (May Day Bride)	Pretending (religious ritual)	Pretend wedding
35	BC	Hunt the egg or "Blind pots" (Beating a pot when it is found.)	Searching and finding	Easter egg hunt
36	BR	Walking on stilts	Balancing, climbing	Walking on stilts
37	BR	"Run Moon" (or plumpsack or clumsy fellow)	(No clear meaning)	NCMG
38	BR	Pulling hair	Tormenting, teasing	Pulling hair
39	BR	Catching insects	Catching, grabbing	Catching insects
40	BR	Child with All Soul's loaf (special bread for religious holiday)	(No clear meaning)	NCMG (hot cross buns)
41	TR	Biting 'plumpsack'	Biting	NCMG
42	TR	Shooting nuts	Shooting	Shooting marbles
43	TC	Gymnastics at the bar	Exercising	Gymnastics
44	TC	Balancing	Balancing	Balancing
45	TC	Tag	Interacting, touching	Tag
46	TC	Rattle	Making noise	Toy rattle

No.	Lo.	Name of Traditional Game	Type of Action Depicted	Comparable Modern Game or Play Activity
47	TL	Jousting with sticks to which pinwheels are attached	Fighting, spinning	Jousting
48	TL	Sandpit	Digging, constructing sand castles	Sandbox
49	TL	Playing king of the hill or king of the castle	Competing, dominating	King of the hill
50	TL	Spinning skirts (or) skirt twirling	Spinning, dancing	Baton twirling
51	TL	Swimming	Swimming	Swimming
52	TL	Tree climbing	Climbing	Tree climbing
53	TL	"Mother, mother where's your child?"	Pretending, identifying	Hide and seek
54	TL	Bowls	(No clear meaning)	NCMG
55	TC	Whipping tops	Spinning	Tops
56	TC	Flag game or imitation of fishing	(No clear meaning)	NCMG
57	TC	Practical joke (hanging shoes or other things out of the window.)	Teasing or joking	Practical joke
58	TR	Skittles (ninepins)	Throwing, aiming	Bowling
59	TR	Variant of hockey	Skating, aiming and shooting the puck	Hockey
60	TR	Ball in the hold	Throwing and catching	Playing ball
61	TR	Bear baiter	Teasing a wild animal	Teasing animals
62	TR	Wall running or running up an incline	Running	Running, esp. uphill
63	TR	Wrestling	Wrestling, competing	Wrestling
64	TR	Throwing coins (against a wall so that they hit the one thrown earlier)	Throwing, aiming	Pitching coins against a wall; closest to the wall wins.
65	TR	Cap game	(No clear meaning)	NCMG
66	TR	Children's procession	Pretending (rituals)	Processing, marching
67	TR	Piggy back	Riding	Piggy back riding

No.	Lo.	Name of Traditional Game	Type of Action Depicted	Comparable Modern Game or Play Activity
68	TR	Singing and clapping	Making music, especially rhythm	Singing and clapping
69	TR	Single file	Obeying	Follow the leader
70	TR	Pushing off the bench	Competing	Pushing another child off a bench
71	TR	Imitating artisans	Pretending	Play doctor, butcher, baker etc.
72	TR	Carrying on the shoulders	Riding	Carrying another person on one's shoulders
73	TR	Fox in the hole	Digging	Digging fox holes
74	TR	Broom balancing	Balancing	Broom balancing
75	TR	Midsummer bonfire or St. John's Fire	Burning in effigy or burning someone at the stake (ritually)	Lighting a bonfire (in protest or in celebration)
76	BL	Carrying an angel (Man and woman make a bridge to carry a child.)	Carrying, supporting	Horseplay with child being carried
77	LR	How many horns does a goat have?	(No clear meaning)	NCMG
78	TC	Looking out of windows	Gazing, dreaming	Day dreaming
79	TC	Dropping something from a window	Surprising an unsuspecting person	Dropping something from a height for the fun of it
80	LR	Inflating a bladder	Pretending (to be pregnant or obese)	Pretending to be pregnant (especially with a pillow)
82	LR	Mumblety-peg	Knife throwing	Mumblety-peg (throwing a knife in order to stick its blade into the ground.)

Appendix 2

PROVERBS DEPICTED IN *THE NETHERLANDISH PROVERBS*
SHOWN BY NUMBER, LOCATION IN PAINTING, WORDING OF
TRADITIONAL PROVERB, MEANING AND COMPARABLE MODERN
PROVERB

Notes concerning the Appendix

Column 1: Numbering of the proverbs follows Vohringer, [43], p. 57

Column 2: Location of proverb refers to its place in the painting
 (TL = Top Left, BL = Bottom Left, TC = Top Center,
 BC = Bottom Center, TR = Top Right, BR = Bottom
 Right)

Column 3: Wording of Traditional Proverb: In listing the proverbs I
 have followed Vohringer, [43], p. 57 and/or Meadow,
 [30], passim.

Columns 4 and 5: The Meaning of the proverb and Comparable Modern
 Proverb/Adage are my wordings. "NCMP" stands for
 "no comparable modern proverb."

No.	Lo.	Wording of Traditional Proverb	Meaning	Comparable Modern Proverb/Adage
1	TL	The roof is covered with dough cakes.	Life is so good that all you have to do is eat the prepared food that slides off the roof of your house.	Some people have everything handed to them.
2	TL	They married under a broomstick.	They had to get married; she was pregnant.	They needed a shotgun wedding.
3	TL	The broom is out.	The master is not home; you can do whatever you want.	When the cat's away, the mice will play.
4	TL	One looks through the fingers.	One misses the point.	S/he just doesn't get it.
5	TL	Thereby hangs the knife.	The challenge is drawn.	They drew a line in the sand.
6	TL	There stand the clogs.	One waits in vain.	NCMP
7	TL	S/he was led by the nose.	S/he was taken.	S/he was had.
8	TL	The dice are thrown.	It's all decided.	The die is cast.
9	TL	Fools get the best cards.	The least deserving are the best rewarded.	Life just isn't fair.
10	TL	It depends on how the cards fall.	We'll just have to see what happens next.	It's the luck of the draw.
11	TL	S/he shits on the world.	S/he scorns the world.	S/he tells the world (everybody) off.
12	TL	The world is topsy-turvey.	Nothing is what it seems.	Appearances are deceptive.
13	TL	Pull through the eye of the scissors.	Gain through dishonesty.	You need to cut corners to get ahead.
14	BL	Leave an egg in the nest.	Always have something in reserve.	Everyone needs a nest egg.
15	TC	Have a tooth bound.	Appear harmless but be sly.	NCMP
16	TC	Piss against the moon.	Try something impossible.	Go to it! Reach for the moon.
17	TL	Old roofs need patching.	Always do the necessary repairs.	NCMP
18	TL	The roof has laths.	There are eavesdroppers. Or, the walls have ears.	This place is bugged.
19	BL	The pot hangs outside.	Use a chamber pot as a sign for an inn. (instead of a tankard)	NCMP

No.	Lo.	Wording of Traditional Proverb	Meaning	Comparable Modern Proverb/Adage
20	TC	Shave a fool without soap.	Mock somebody.	NCMP
21	TC	Grow out of the window.	The truth seeks the light.	Sooner or later, it will all come to light.
22	TC	Two fools under a single cap.	Folly loves company.	We're both in the same boat.
23	TL	Shoot off all your arrows.	Leave nothing in reserve.	Don't be brash and shoot your wad.
24	BL	Tie the devil to a cushion.	Everything is possible.	NCMP
25	BL	Bite the pillar.	Be hypocritically religious.	NCMP
26	BL	She carries fire in one hand; water in the other.	She is insincere.	She (he) speaks out of both sides of the mouth.
27	BL	a. Fry the herring for the roe. (or) b. The herring is not frying.	a. Obtain little benefit. (or) b. Things are not going according to plan.	That is a half-baked idea.
28	BL	Wear a lid on the head.	Maintain control.	Keep a lid on things.
29	BL	a. Have more in him than an empty herring. (or) b. The herring hangs by the gills.	a. Have unexpected depths. (or) b. Mistakes have consequences.	NCMP
30	BL	Sit between two stools or in the ashes.	Be unable to decide, achieve nothing.	a. Be stuck between a rock and a hard place. (or) b. Be caught on the horns of a dilemma.
31	BL	Smoke cannot hurt iron.	Better to abandon pointless ventures.	Don't throw good money after bad.
32	BL	Spindles fall in the ashes.	All is lost.	Everything turned into dust.
33	BL	If you let the dog in, it creeps into the cupboard.	Small acts can have big consequences.	Give an inch and s/he will take a yard.
34	BL	The sow is pulling the bung (anus) out.	Bad administration.	They're doing a half-assed job.
35	BL	a. Bang your head against a brick wall. (or) b. Go through the wall with your head.	a. Waste effort; (or) b. Be stubborn.	Sometimes you just hit your head against the wall and get nowhere.
36	BL	Be up in arms.	S/he was up in arms.	NCMP

No.	Lo.	Wording of Traditional Proverb	Meaning	Comparable Modern Proverb/Adage
37	BL	Put a bell on the cat.	Do something all too publicly.	Don't advertise it to everyone.
38	BL	a. Armed to the teeth; (or) b. Be an iron-eater.	Have a knife between one's teeth.	He's so tough he eats nails for breakfast.
39	BL	Feel the hen.	Take trouble too soon.	NCMP
40	BL	Gnaw the bone.	The food is meager.	We're down to the bare bones.
41	BL	The scissors are hanging out.	Said of a cutpurse or swindler in wait for a victim.	Watch your wallet; this place is full of thieves.
42	BL	Speak with two mouths.	Say two things at the same time.	S/he speaks with forked tongue.
43	BL	One shears sheep, the other swine.	Identical work is not rewarded equally.	Life is not fair.
44	BC	A lot of squealing, not much wool.	All talk and no action.	Where's the beef?
45	BL	Sheer it but don't flay it.	Don't go for profit at any cost.	Don't kill the goose that laid the golden egg.
46	BL	Patient as a lamb.	To be passive.	S/he was like a lamb about to be led to the slaughter.
47	BC	Distaff that others spin.	Pass on malicious gossip in parrot fashion.	What goes around comes around.
48	BC	a. Take care no black dogs get in the way. Or b. Whenever two women are together, no baying hound is needed.	It could go wrong.	Beware the black cat that crosses your path.
49	BC	Carry out the light in baskets.	Do the impossible.	NCMP
50	BC	Light candles for the devil.	Flatter everyone.	NCMP
51	BC	Confess to the devil.	Carry secrets to one's enemies.	NCMP
52	BC	An ear-blower.	A schemer or a plotter.	NCMP
53	BC	The crane invites the fox to supper.	One invites conmen in.	The big bad wolf appears in sheepskin.
54	BC	An empty plate may be lovely.	Bodily needs come before the senses.	You can't eat beauty.

No.	Lo.	Wording of Traditional Proverb	Meaning	Comparable Modern Proverb/Adage
55	BC	A skimmer.	One who takes the cream from the milk.	The crooked person skims money "off the top."
56	BC	Be chalked up.	S/he is already tainted.	That person has a black mark against her/him.
57	BC	Fill the well after the calf has drowned.	Do something before it is too late.	Close the barn door before the horse gets out.
58	BR	Make the world dance on his thumb.	Rule all-powerfully.	S/he's got the world on a string.
59	BR	A spoke in the wheel.	We're only small players in a big world.	We are all just cogs in the wheel.
60	BC	To make your way in the world you must writhe.	You will not get anywhere without trouble.	To get ahead, you need to worm your way in.
61	BR	Put a false beard on Christ.	Denotes false piety.	Don't be such a hypocrite.
62	BC	Throw roses (pearls) before swine.	Waste treasures on savages.	Don't throw pearls before swine.
63	BC	She's draping a blue coat on her husband.	She's cheating on him.	She's pulling the wool over his eyes.
64	BC	The pig has been struck through the belly.	The decision has been made and is irrevocable.	One's goose has been cooked.
65	BC	Two dogs seldom agree over one bone.	Greed and envy prevail.	It's a dog-eat-dog world.
66	BR	Sit on hot coals.	A cat sits on hot bricks to stay warm.	NCMP
67	BC	a. The meat on the spit must be basted, (or) b. Pissing on the fire is healthy, (or) c. His fire is pissed out.	a. It's all in the preparation.	Expect the best but prepare for the worst.
68	BC	No spit can turn with him.	(No Clear Meaning)	NCMP
69	BC	Catch fish by hand.	Be crafty. Let others do the work because he's robbing other people's nests.	There are many ways to skin a cat.
70	RR	Cast for a cod with a smelt.	Do a pointless and obviously loss-making action.	Fiddle around while the fire destroys everything.

No.	Lo.	Wording of Traditional Proverb	Meaning	Comparable Modern Proverb/Adage
71	BR	Fall through the basket.	To fail.	Fall through the cracks.
72	BR	Hang between heaven and earth.	Be in an awkward situation, where it is difficult to make a decision.	Be caught on the horns of a dilemma.
73	BR	Take the chicken's egg and leave the goose's.	Make the wrong decision.	NCMP
74	BR	Yawn at the oven.	Act with futility.	NCMP
75	BR	Not reach from one loaf to the next.	Have too little money.	Be unable to make ends meet.
76	BR	Look for the hatchet.	Pick a quarrel.	Be the hatchet man, i.e., the enforcer.
77	BR	Here he is with his lantern.	He can shine.	One can/should be a beacon of light.
78	BR	If you spill the porridge, you won't save everything.	Sometimes it's too late.	NCMP
79	BR	They're drawing it out.	Each person stakes out his or her own advantage.	They are drawing battle lines.
80	BR	Love is on the side where the purse is.	One's heart is with his/her money.	Neither love nor money will make him/her do it.
81	BR	a. Place oneself in the light, (or) b, No one looks for another person in the oven unless he's been in it himself.	Those who think evil attribute evil to others.	It takes one to know one.
82	TC	Play on the pillory.	Anyone who is already accused should not draw more attention to him/herself.	Keep a low profile if you don't want to be caught or caught again.
83	TC	Fall from the ox on to the ass.	Do bad business.	Go from the frying pan into the fire.
84	TC	The beggar is sorry if there's another beggar at the door.	There is competition in everything.	One can't win them all.
85	TC	He can see through an oaken plank (only) if there's a hole in it.	He can't perform miracles.	NCMP
86	TC	Rub your backside on the door.	Show disdain for those inside.	Moon them.

No.	Lo.	Wording of Traditional Proverb	Meaning	Comparable Modern Proverb/Adage
87	TC	He carries his little pack.	Everyone has a burden to bear.	We all are worn down by a pack of troubles.
88	TC	He kisses the ring.	He manifests false reverence.	NCMP
89	TC	Fish behind the net.	Miss a chance; be too late.	One needs to fish or cut bait.
90	TR	Big fish eat little fish.	The powerful absorb the small fry.	Learn to swim with the sharks.
91	TR	He's upset that the sun shines into the water.	He's full of resentment.	S/he has an attitude.
92	TR	Throw money in the water.	Waste money.	S/he has money to throw away.
93	TR	They shit through the same hole.	They are inseparable.	They are two peas in a pod.
94	TC	Hang like an outhouse over the ditch.	(No clear meaning)	NCMP
95	TC	Catch two flies with one swat.	Accomplish two goals in one effort.	Kill two birds with one stone.
96	TC	Watch the stork.	Waste time.	Just sit, take it easy and watch the world go by.
97	TC	You know a bird by its feathers.	People always reveal their true selves.	You always know a bird by its feathers.
98	TC	Hang your mantle according to the wind.	Manage to catch favorable trends.	Trim your sails to the wind.
99	TC	Shake feathers into the wind.	Work at random.	Go every which way.
100	TR	Other people's skin make good belts.	It's easy to be generous with other people's possessions.	Nothing is easier than spending another person's money.
101	TR	The pitcher will go into the water until it breaks.	There's a limit to everything.	Things are bursting at the seams.
102	TR	Catch an eel by the tail.	Do something that is bound to fail.	Let opportunity slip by.
103	TR	He is hanging his habit over the fence.	He is getting a new start with uncertain prospects.	NCMP
104	TR	It is difficult to swim against the stream.	It's easier to be accommodating.	It is an uphill battle. Don't swim against the tide.

No.	Lo.	Wording of Traditional Proverb	Meaning	Comparable Modern Proverb/Adage
105	TR	a. He can see bears dancing, (or) b. Bears like each other's company.	a. He is hallucinating from starvation. (or) b. Humans do not enjoy each other.	NCMP
106	TC	a. He is running as if his pants were on fire, (or) b. Eat fire and you'll shit sparks.	a. He is in a panic, (or) b. Sow the wind and reap the whirlwind.	b. We all sow the seeds of our own destruction.
107	TC	a. If the door is open, the pigs run into the corn; (or) b. If the corn is decreasing, the pigs are increasing.	Advantage and disadvantage are often linked.	Sometimes the best offense is a strong defense.
108	TR	He doesn't care whose house is on fire as long as he can warm himself.	Take every profit with you.	Do whatever it is you have to do.
109	TR	Cracked walls are soon destroyed.	A bad outcome is foreseeable.	S/he had to have seen it coming.
110	TR	It's easy to sail with a following wind.	When conditions are right, success is easy.	S/he simply breezed through life.
111	TR	Have an eye on the sail.	Keep a good watch.	Keep your eye on the ball.
112	TR	a. Who knows why the geese go barefoot? or b. If I'm not to be a goosehead, I'll leave the geese to the geese.	There's a reason for everything.	Everything has its time and its place.
113	TR	Horse droppings are not figs.	Don't be taken in.	Don't take any shit (from anyone).
114	TR	He's sharpening a log.	He's engaging in pointless dedicated effort.	He is whistling Dixie.
115	TR	Fear makes old women run.	Need makes the impossible possible.	You have to do what you have to do.
116	TR	Shit on the gallows.	a. Cheat the gallows, (or) b. Fear nothing.	Do whatever you have to do to make it.
117	TR	Where there's carrion, there are crows.	Garbage attracts scavengers.	Garbage in; garbage out.
118	TR	When the blind lead the blind, they both stumble.	One must know to whom he is entrusting himself.	Always watch your backside.
119	TR	The journey is not over when you descry church and tower.	Don't crow too soon.	It's not over until it's over.

Index

Overleaf (Plate 36)
The Netherlandish Proverbs 1559
Oil on panel, 46 x 64 1/8 in
Gemaldegalerie, Staatliche Museen zu Berlin, Inv. 1720
Berlin

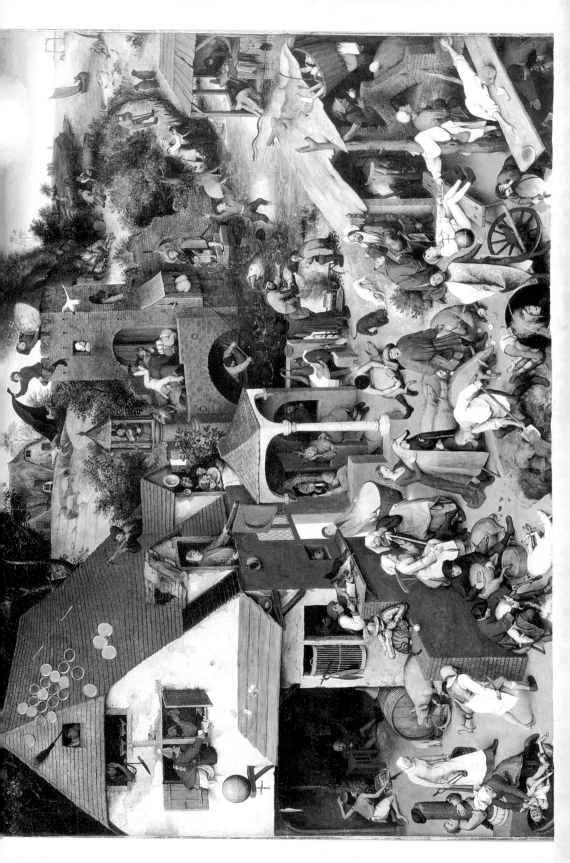